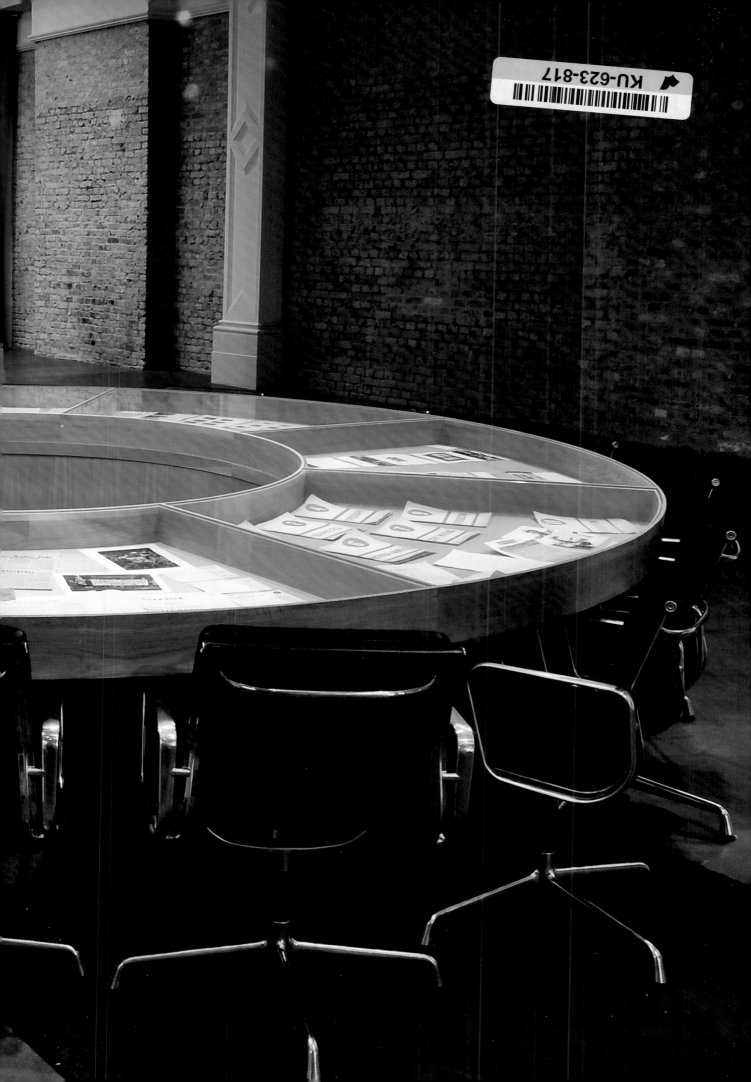

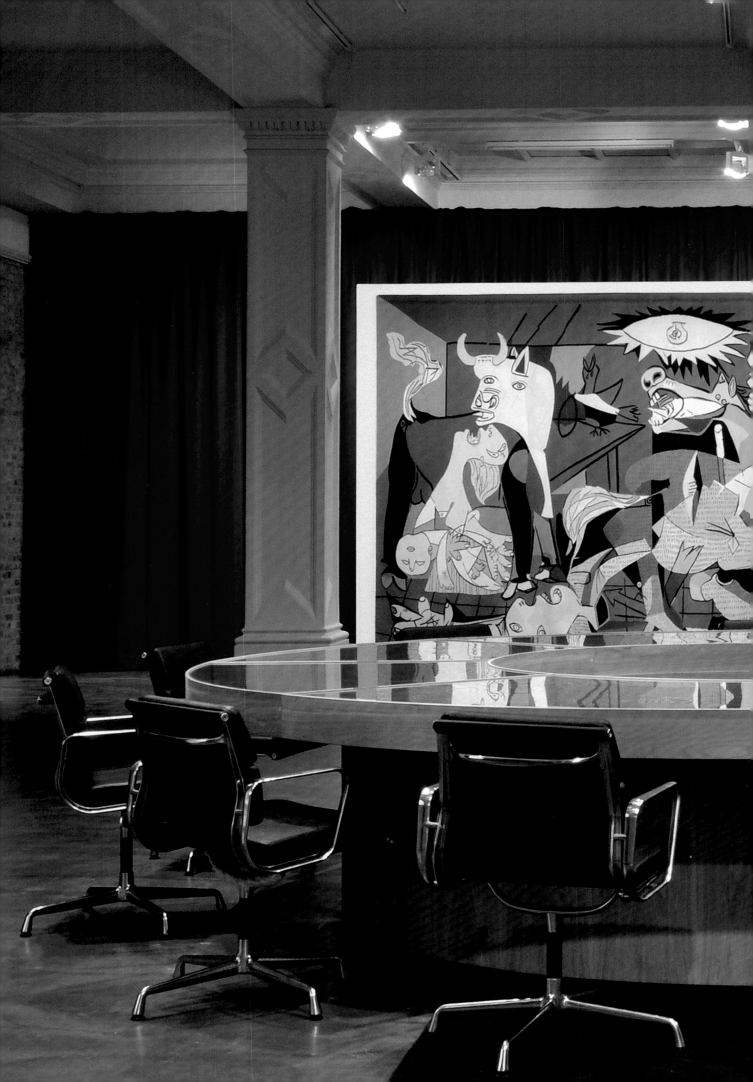

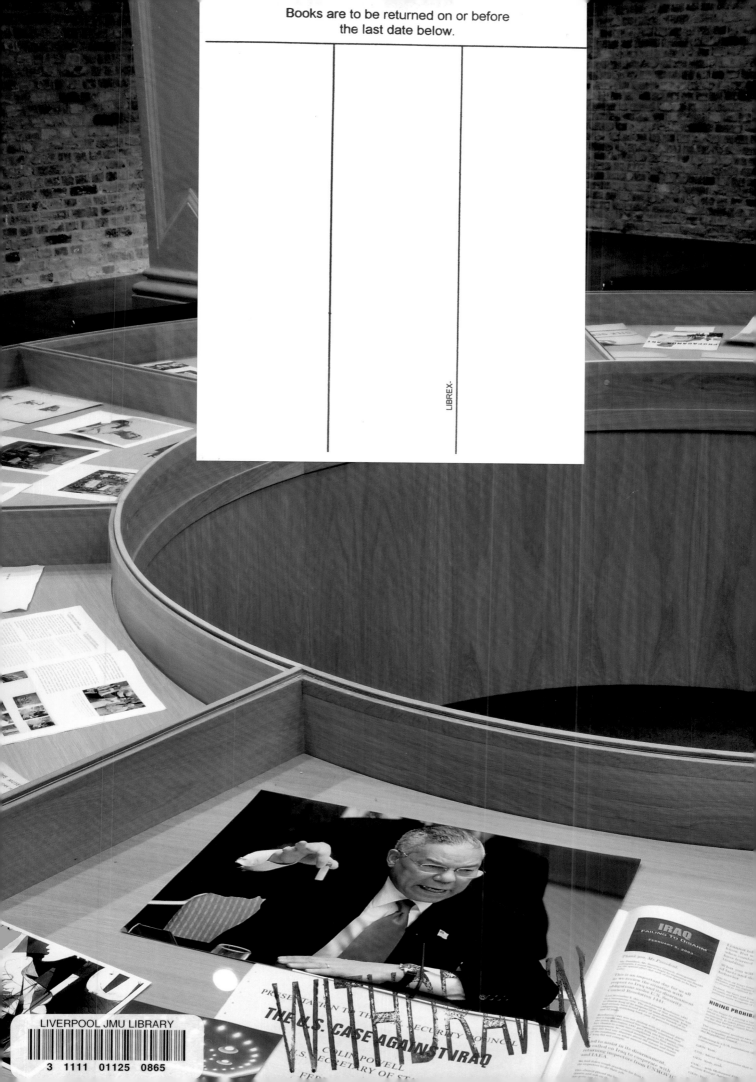

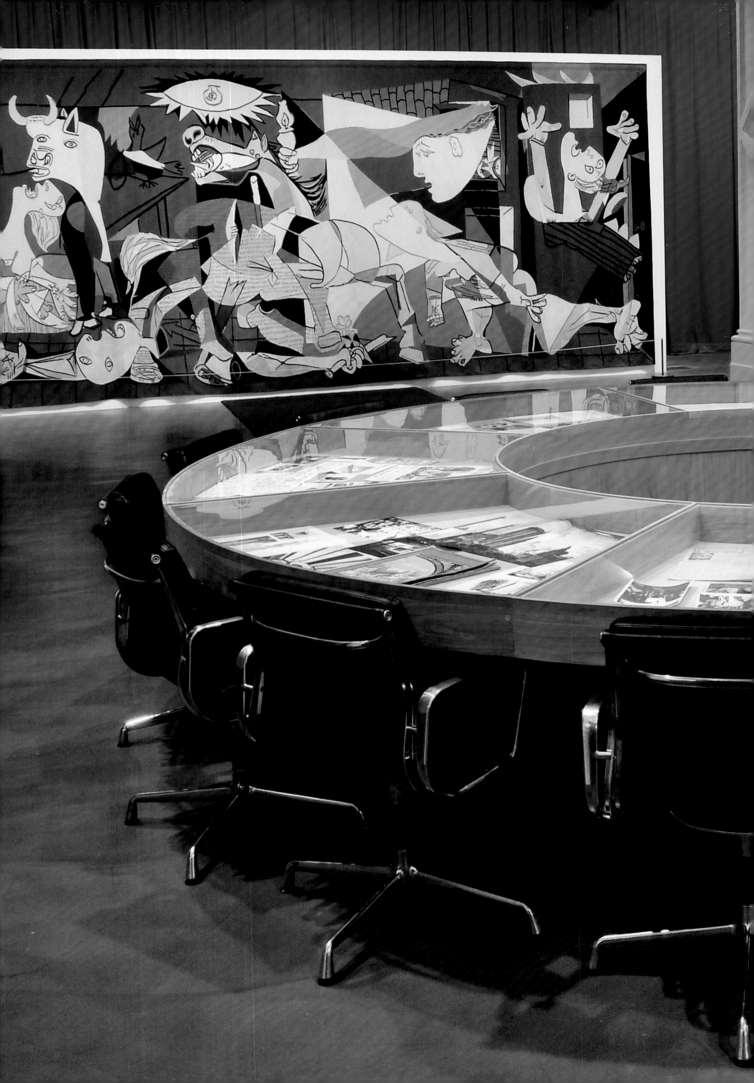

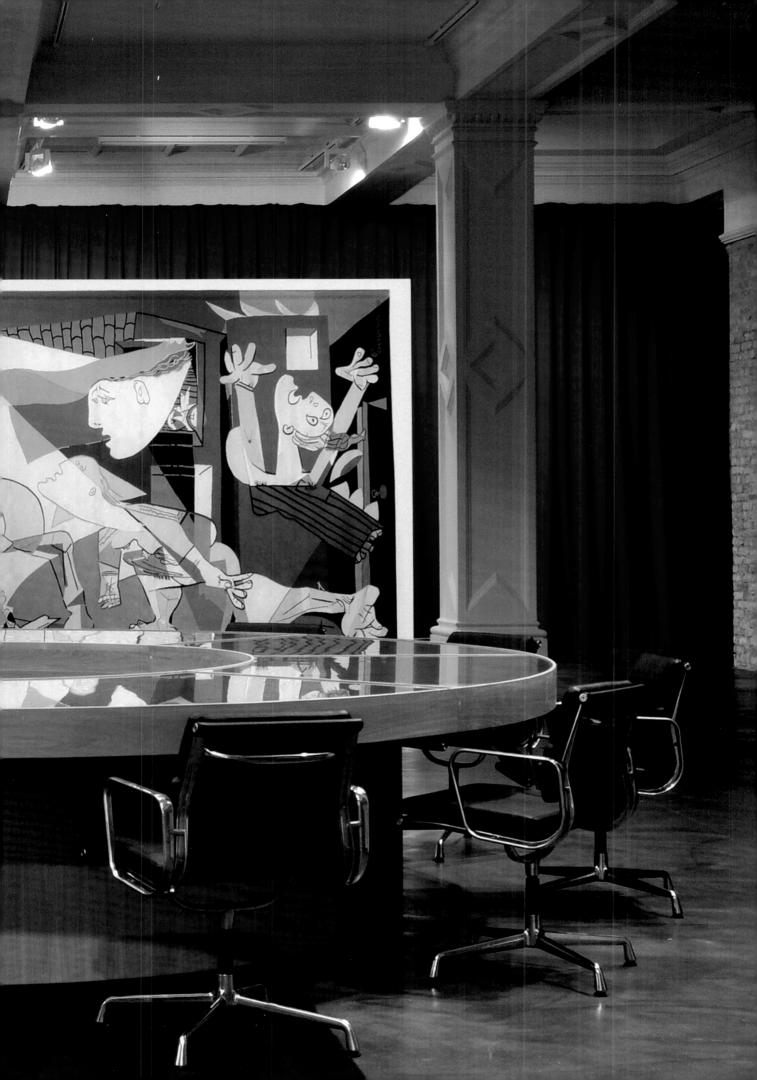

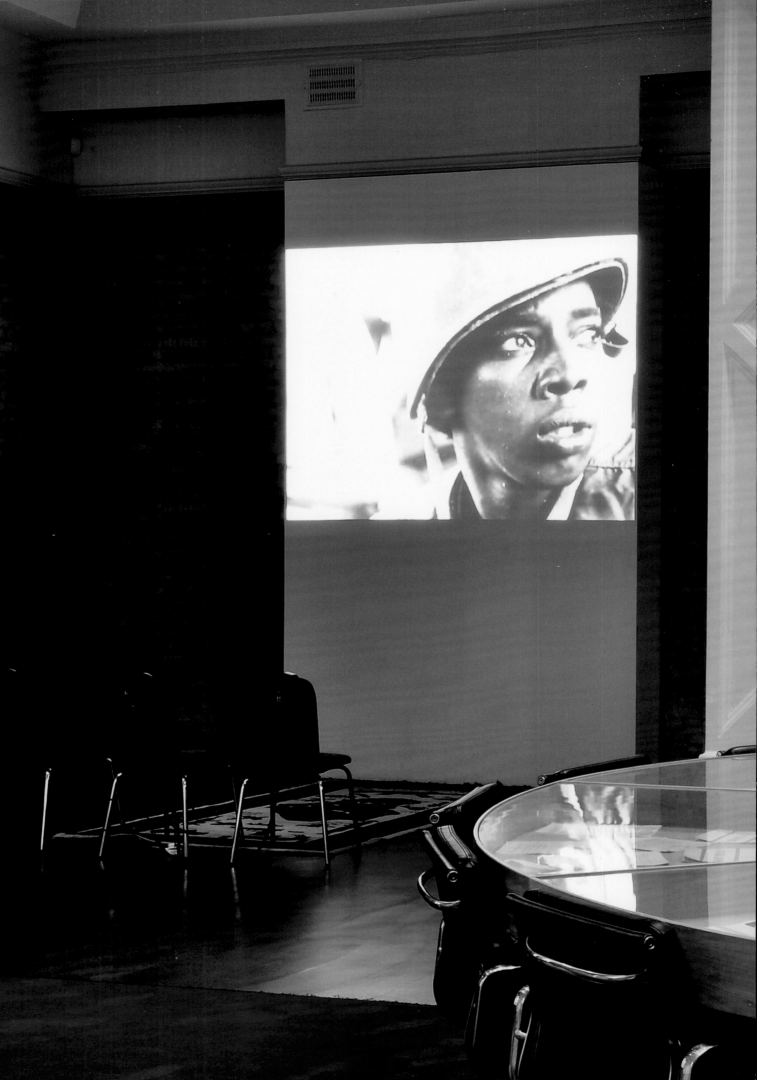

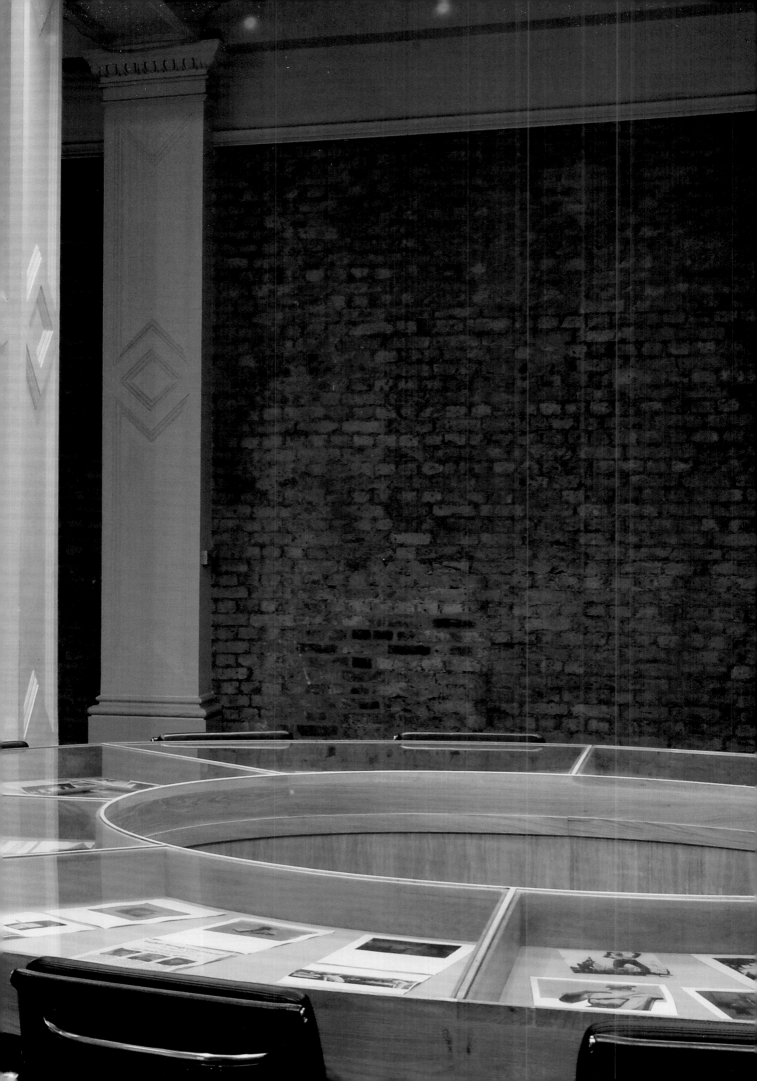

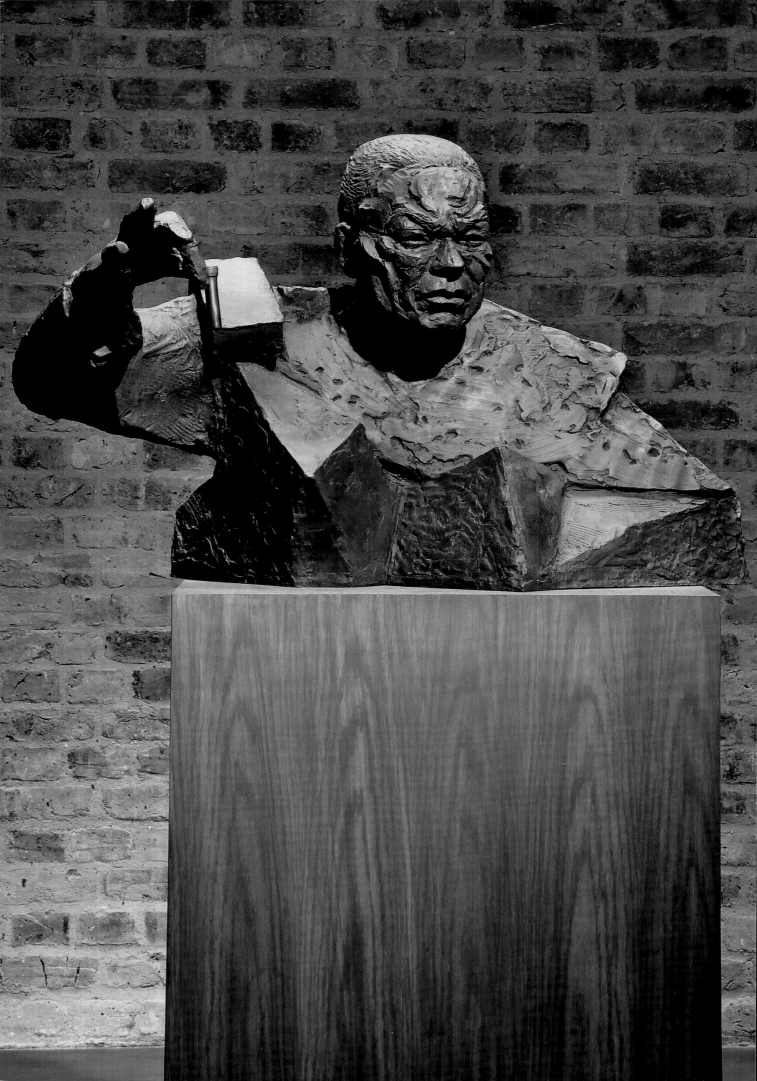

GOSHKA MACUGA
THE NATURE OF THE BEAST

Whitechapel Gallery

Contents

Foreword

Goshka Macuga is a Polish artist who has lived and worked in London for the past 20 years. A predominant feature of her practice is the adoption of the methods associated with archiving and museum display. However, as an artist she is freed from the usual constraints associated with more curatorial and academic approaches to these areas. Instead, Macuga applies the techniques of bricolage and collage to construct her own complex mesh of often overlooked connections and forgotten details, providing a fascinating insight into the material that she works with.

When Goshka Macuga was invited to make the first Bloomberg Commission for the former Whitechapel Library Reading Room, the full impact that her project would have in weaving together the history of Picasso's *Guernica* with that of the Whitechapel Gallery could not have been envisaged. *The Nature of the Beast* has not only highlighted a specific moment in the Gallery's long history, but it has also generated a rich body of material around the project which will ultimately be deposited in the Whitechapel Gallery Archive.

Looking back through a prism of the political context of wars in Iraq, Afghanistan and on 'terror' more generally, Goshka Macuga has chosen a moment from the Gallery's past to focus on and recontextualize. In 1939, Picasso's original painting *Guernica* was shown at the Whitechapel Gallery. Painted in response to the bombing of the Basque town of Guernica by German aircraft in support of Franco's forces during the Spanish Civil War, the painting was brought to London by the Spanish Relief Campaign to raise awareness of the conflict. Fast forward to 2009 and Macuga has created a project that refers to multiple political moments that surround the *Guernica*, in both its forms as painting and as tapestry. Starting with the initial lectures and political rallies that occurred in 1939, then moving to the various attempts to bring the work back to the Whitechapel Gallery in 1952 and 1981, and the now infamous incident when the tapestry version that hangs in the United Nations Headquarters was covered by a blue curtain during Colin Powell's speech stating the case for the Iraq invasion in 2003; all of these various points are touched upon within the work.

In addition to this, Goshka Macuga created a platform for a myriad of other big and small political events to take place within her project. The central, round meeting table partly inspired by the table of the United Nations Security Council was available for groups to use for discussions and gatherings. There was no fee charged nor a process of selection, the only proviso being that a visual and written record was supplied that would be archived. The meetings have provided a microcosm of how the political plays out through contemporary British society, from organized political movements, to local government bureaucracy, to activism and self-organized groups gathered around a particular issue.

The success of the project would not have been possible without the presence of the *Guernica* tapestry itself, brought to London from the United Nations Headquarters in New York. We would like to thank Mrs Nelson Rockefeller and Cynthia Bronson Altman for their cooperation in making this crucial loan possible.

We would like to give our thanks to the authors Cynthia Bronson Altman, Carolyn Christov-Bakargiev, Pablo Lafuente, Sally O'Reilly, Dieter Roelstraete and Nayia Yiakoumaki who have all provided such fascinating insights into the various aspects of this complex and multilayered work. The publication also brings together a number of projects that are linked (at times overtly, at others more implicitly) in their approach to practice and in their structure. We would like to thank Dieter Roelstraete for his second text which contextualizes Goshka Macuga's practice to date. We are also grateful to the book's designer Fraser Muggeridge for his work in making such a wonderful publication.

We would like to thank the Whitechapel Gallery's staff that have worked on the project, specifically Curator Anthony Spira, Exhibitions Organizer Cassandra Needham, Public Events Assistant Nicola Sim, and interns Will Cooper, Elizabeth Eames and Paula Morison. The contribution that Nayia Yiakoumaki, Archive Research Curator, and Archivist Gary Haines have made to the project has been invaluable in terms of opening up the archive to Goshka Macuga and drawing material from it for the project.

We would not have been able to finance this ambitious project and accompanying publication ourselves. The Whitechapel Gallery would like to express gratitude for the generous support of Bloomberg reflecting their commitment to innovation and their ongoing efforts to expand access to the arts, science and humanities. We are also extremely grateful to the Adam Mickiewicz Institute and their POLSKA! YEAR festival within which Goshka Macuga's project was presented; the Henry Moore Foundation, the Polish Cultural Institute and the Wingate Scholarships whose generous contributions all helped us realize the artist's vision. We would also like to thank Goshka Macuga's London gallery Kate MacGarry and Andrew Kreps in New York for their invaluable support.

Finally it is to Goshka Macuga that we are most deeply grateful; her unique artistic vision has provided a crucial moment of reflection on the Gallery's rich history as we embark on the next stage of its development.

Iwona Blazwick OBE
Director

Kirsty Ogg
Curator

Dieter Roelstraete

Unmaking Worlds: Goshka Macuga and the Art of Dis/Assembly

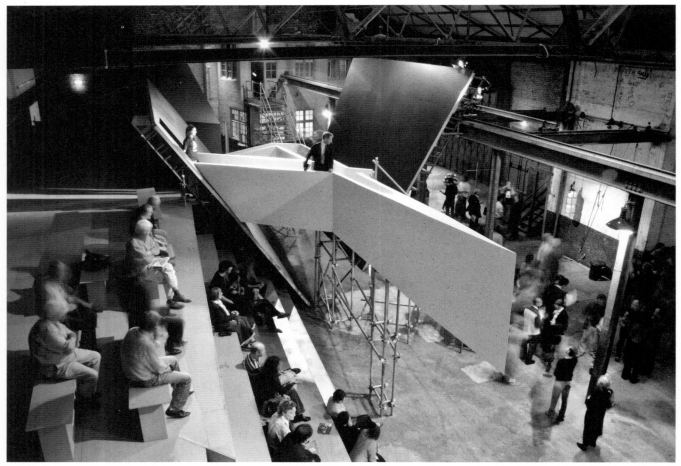

Goshka Macuga, *Sleep of Ulro*, 2006
Installation view, A Foundation / Greenland Street, Liverpool
Courtesy Kate MacGarry, London. Photograph Rob Meighen

If the art made since 1990 can be characterized or described, at least in part, by terms and/or formulas such as 'historiographic turn' and 'archival impulse', a related rubric could be termed the 'curatorial turn.' With this concept, I do not merely aim to typify the equivalent, in terms of artistic production, of the cultural ascendance of the figure of the curator in the period described. In the first instance, such a label serves to circumscribe a richly textured array of artistic practices that share an interest in archival research; collaborative processes that regularly require the crossing of disciplinary borders; the interrogation of such notions as authenticity, authority and authorship; and the politics of display (this is where this 'curatorial turn' can be shown to overlap with the tradition of institutional critique). For some time now, Goshka Macuga has been a leading practitioner in this field; an artist whose artworks routinely take on the shape of installations that look like (and often simply *are*) elaborate group exhibitions which include (or mimic) the work of other artists. The most spectacular example of this artist-as-curator modus operandi is still Macuga's massive *Sleep of Ulro*, which premiered at the 2006 Liverpool Biennale: a sprawling, immersive environment reminiscent of an old German Expressionist film set. This labyrinthine structure-cum-cabinet-of-curiosities housed works by Matthew Leahy, Melvin Moti, Paul Nash, Roxy Paine and David Thorpe alongside Etruscan figurines, meteorites, mounted dugong ribs, and remnants of a Rudolf Steiner-inspired performance.

If one thing could be called central at all in this radically decentred, associative accumulation of bewitching visual facts — named after the opening lines of a William Blake poem — it was perhaps the spectral, hovering figure of Madame Blavatsky, the founding matriarch of theosophy; a symbolic stand-in for the artist's sustained interest in all kinds of secretly passed-on knowledge, in the subterranean, the chimerical and the clandestine. 'Secret knowledge', with the emphasis firmly placed on the latter, not the former: indeed, its programmatic fascination with mysticism and the world of the occult notwithstanding, Macuga's research-heavy work does stay true to a quasi-scientific spirit of enquiry. Nowhere is this made more clear than in her engagement with the protean figure of renegade art historian Aby Warburg, the central figure and ultimate subject of *I Am Become Death* (Kunsthalle Basel, 2009). In its conflation of contemporary art lore, cultural history, and post-war geopolitics, this emblematic project is perhaps the artist's most complex and rewarding to date. In it, Aby Warburg's turn-of-the-century travels to Navajo and Hopi Land to witness the latter's fabled snake dance ritual intersect with Macuga's own trip across the United States in search of a Vietnam veteran whose personal photo archive she managed to acquire online — all of this framed within the idiosyncratic context of a sculptural remake of a Robert Morris exhibition organized at Tate Britain in 1971, the interactive nature of which caused the breaking of not just a few overly enthusiastic visitors' limbs.

A motley crew of references perhaps, but Warburg, though hardly appearing in person, is undoubtedly the true hero of this work (named after a quote attributed to Robert Oppenheimer, one of the fathers of the

Goshka Macuga, *I Am Become Death*, 2009
Installation view, Kunsthalle Basel

atomic bomb). It is noteworthy that, along with Macuga, a number of artists have in the meantime taken an avid interest in the work of Warburg, this long-marginalized pioneer of iconology, whose take on art-historical orthodoxy is probably best described as curatorial indeed. Theirs, like his, is an art of unconventional juxtapositions and Borgesian classifications, of wild leaps of thought and funky flights of fancy, all aimed at subverting or dismantling the canonical view of (art) history, at unmaking the world as we know and found it – in other words a deeply critical project. In this regard, it is certainly worth mentioning Macuga's *When Was Modernism?*, produced for the exhibition *Santhal Family: Positions Around an Indian Sculpture*, which was curated by Grant Watson at the Museum of Contemporary Art Antwerp (MuHKA) in 2008 – the question mark in the title operated as a vestigial trace of the question to be asked, rightfully and relentlessly, of *all* Eurocentric orthodoxies ('*where* was modernism?' as much as '*when* was modernism?'). Or of the orthodoxies of patriarchy as it continues to shape our understanding of western art history – the secretive subject, one might say, of both *Objects in Relation*, shown at Tate Britain in 2007, and *Haus der Frau I & II* and *Deutsches Volk/Deutsche Arbeit* shown at the 2008 Berlin Biennial, both portraits of uneven relationships between well-known creative men and lesser-known creative women (Paul Nash and Eileen Agar and Ludwig Mies van der Rohe and Lilly Reich respectively).[1]

The casually mentioned ghosts of Oppenheimer and the Vietnam War already hint at the progressive politicization (if we may put it so bluntly) of Macuga's more recent work, a process which reached its logical apogee, for now, in two major tapestries produced in 2009: the Guernica-cum-Bush-inspired *On the Nature of the Beast* (not to be confused with the work titled *The Nature of the Beast* for the Whitechapel Gallery), and *Plus Ultra*, on view in the Arsenale during the 2009 Venice Biennale (the title of which, *Making Worlds*, could well act as a subtitle to Macuga's practice as a whole). Wrapped, banner-like, around two monumental pillars supporting a section of the Arsenale's imposing roof, *Plus Ultra* alluded firstly to the mythical Pillars of Hercules (the present-day Strait of Gibraltar), formerly believed to mark the end of the known world, beyond which nothing else lies (*nec plus ultra*). It also included references to Emperor Charles V, however, in whose sixteenth-century realm the sun famously never set (*plus ultra* being the motto of his colonial ambitions), and an enthusiastic patron of textile art on the grand, truly regal scale.

Macuga's update of this archaic art form – craft is another red thread that runs through much of her work, once again invoking the spectre of art history's skewed gender politics along the way – features a faux-naively rendered group portrait of the leaders of the G20 (opposite an image of Charles V, his face masked by a dollar sign), as well as New York's Twin Towers engulfed in flames and smoke (an obvious mirror image of the Pillars of Hercules depicted on the left) and a boat loaded with African refugees hoping to make their way across the Strait of Gibraltar, into 'Fortress Europe.'

Goshka Macuga, *When was Modernism?*, 2008
Installation view, *Santhal Family: Positions Around an Indian Sculpture*, MuHKA, Antwerp
Courtesy Kate MacGarry, London and MuHKA, Antwerp. Photograph Clinkx/MuHKA

1.
Objects in Relation is perhaps the one work in which Macuga gave her 'archival impulse' the freest rein, as the Tate's own archive functioned as the primary source for all of the pictorial materials shown in this particular installation. Like the Berlin work based on a reconsideration of Mies' and Reich's relationship however, it can also be read as 'proof' that important segments of art history can always be rewritten as a history of *personal* relationships, of love affairs.

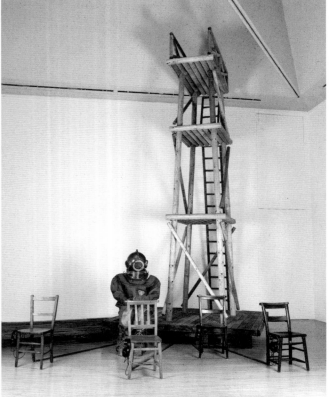

Goshka Macuga, *Objects in Relation*, 2007
Installation view, Art Now, Tate Britain, London
Courtesy Tate and Kate MacGarry, London

All this, it is worth remembering, installed inside the former arsenal of what was once Europe's mightiest naval power, who authored an early blueprint of the colonial enterprise – proving that Macuga does not shy away from the political consequences of site-specificity.

Looking back at the slightly crazed faces that stare down at us from *Plus Ultra* and thinking back to the deranged cubist portrait of Colin Powell, anthrax phial in hand, overlooking the conference table in *The Nature of the Beast*, it is tempting to presume the presence of a good deal of measured madness at the heart of Macuga's method – and here too, the iconic, mercurial figure of Aby Warburg returns to the fore. Warburg, a self-proclaimed, 'Hamburger at heart, Jew by birth, Florentine in spirit,' was one of the first to put the famous Nietzschean dyad of the Apollonian and the Dionysian as the complementary constituents of all human culture to the test of scientific historical research. This showed that the complacent, established view of Renaissance Italy as an early high-water mark of the human propensity to harmonious, rationalist thought in fact served to obscure a deep-seated sense of the irrational in many of its most highly regarded cultural practices. Like Nietzsche, though less spectacularly so, Warburg spent the last decade of his life battling the demons of deteriorating mental health – a painful reminder, perhaps, that no-one lifts the lid off Pandora's box with impunity. And as was the case with Nietzsche, the world has come round to reversing its stubborn earlier dismissal of Warburg's life work; artists in particular have played an important role in this process of critical reappraisal; artists (like Goshka Macuga) above all have a stake in showing that what is presently considered mad by many is in all probability nothing other than the sound thinking of the future – a future so fearful that we should be forgiven for going insane.

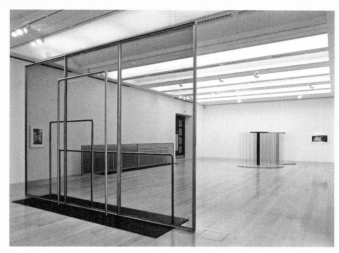

Goshka Macuga, Turner Prize installation, Tate Britain, London, 2008
Courtesy Kate MacGarry, London. Photograph Andy Stagg

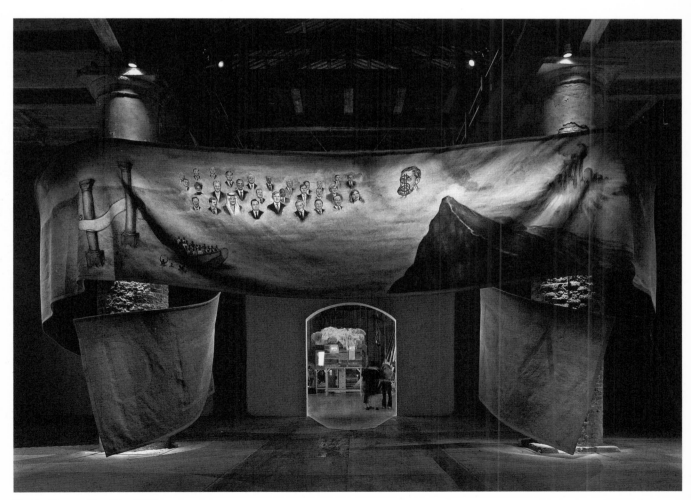

Goshka Macuga, *Plus Ultra*, 2009
Installation view, 53rd Venice Biennale
Courtesy Fondazione Sandretto Re Rebbaudengo, Turin and Kate MacGarry, London. Photograph Andy Stagg

Carolyn Christov-Bakargiev

On Macuga and
The Nature of the Beast

Goshka Macuga's art is grounded in the possibility of
creating a complex and layered narrative where historical
meaning might emerge, not as a set of communicated
'true' facts but rather as forms of intensity and agency
through story-telling and palimpsest.

Macuga's 2009 project, *The Nature of the Beast*
at the Whitechapel Gallery was a 'room' where different
yet related elements were there to be used – it was
a performative platform with a table at the centre, a
tapestry on a wall towards the back of the space,
a rug on the floor, films playing on a wall near the rug,
a bronze sculpture, and a pile of newspapers. It was
like the space of a dream – with substitutions, removals,
condensations, shifts, and other occurrences creating
a surreal atmosphere. It was normal and absolutely
unusual – the tapestry looked like Picasso's *Guernica*
(a painting created shortly after the town was bombed
on 26 April 1937, the first large-scale aerial attack
in history on civilians); the table and chairs looked like
furniture found in a corporate board room; the sculpture
looked weirdly modernist yet was terribly familiar to
our times.

For this work, the artist borrowed the 1952 tapestry
version of *Guernica*, which normally hangs outside the
Security Council meeting room at the United Nations
Headquarters in New York. She used it as both a focal
point and backdrop in a space which served a double
function as a meeting room and a physical archive.
More than 100 meetings of community-based groups,
grassroots organizations and others devoted to a
broad range of current issues were held in this space
throughout the time of the exhibition. At the centre
of this heterogeneous space was a round table with
a glass top that created a vitrine. Its shape recalled
the UN Security Council's circular table, and it was
surrounded by corporate-looking copies of Eames chairs
that were used by visitors and participants in the various
meetings. Contained within the table/vitrine, in eight
separate sections, were documents on a range of
subjects including the exhibition of Picasso's original
Guernica alongside a Calder fountain in the Spanish
Pavilion at the Paris International Exhibition in 1937,
and its subsequent display at the Whitechapel Gallery
in 1939 to raise support for the anti-fascist Republicans
fighting in the Spanish Civil War, as well as a later,
failed attempt to borrow the painting again from the
Museum of Modern Art in New York to be included
in a solo exhibition of Picasso's work at Whitechapel
Gallery. Also included were documents from the Estate
of Norman King, a trade unionist who informally taught
how to make propaganda as a form of political activism
in London in the late 1930s. The space also displayed
elements relating to the recent war in Iraq, including
a bronze bust of Colin Powell with his arm raised holding

a small tube of anthrax, evoking the speech, held at the United Nations in New York on 5 February 2003, in which he argued for war on Iraq, a performance that was obsessively repeated in the media at the time. A newspaper distributed as part of the project transcribes this speech. Opposite this bust, was an Afghan war rug,[1] and a projection screen showing a selection of films and excerpts about the repetitive patterns of war, including *Winter Soldier* (Winterfilm Collective, 1972), *Guernica* (Antony Penrose, 1984), and *Fallujah: The Real Story* (Ali Fadhil, 2005).

There is a circulation of signs, elements and materials, a back-and-forth movement between art and its codes, the world and our engagement with it through activism and political agency. The very room at the Whitechapel Gallery in which Macuga's work was installed, was originally the reading room of the neighbourhood library. Macuga thus created an installation that actually went *against* the renovation and transformation of the place into a neutral site for the display of contemporary art and reverted it to its original usage – to bring people into a space of learning, social interaction and self-development.

Macuga studied exhibition design in Poland, before studying fine arts in London. She is a collector of materials and object-based information, often including other artists' works in her own projects. Her guiding principle is not to give a set structure or methodology to practice, but rather to be freer through this heterogeneous practice, which also involves researching, archiving, collecting and displaying aggregations of elements in a discursive and archeologically creative practice. In her work, exhibition design is transformed into artwork, curatorial practice reworked as artistic practice. Since the late 1980s and throughout the 1990s, the artworld has witnessed a steady increase in the visibility of the curatorial role and practice, parallel to the rise of discursive-based exhibitions and art practices. This has shifted the attention away from a traditionally modernist sense of the autonomy of the artwork towards a more engaged view of art's place in the world. This rise of the curatorial also runs parallel to a de-cursive decrease in artistic agency and in the voice of artists, which may also be seen as part of a larger and highly problematic endeavour to systematize and organize and ultimately transform art into a stable field of production of immaterial labour within a rising knowledge-based economy. From this point of view, Macuga's radically free set of associations, and her assumption of the role of the exhibition-maker becomes a strategic move towards artistic emancipation from such forms of intellectual mediation and control.

Two apparently unrelated questions have occupied much of the debate around contemporary art in recent years. On the one hand, there is the question of collaborative artistic practice and collective action while, on the other, lies the question of the archive, its practice and its politics. The performative nature of Macuga's project was based on the agency and emancipatory potential embedded in the dynamic network of linkages she set up between these two questions. In and through historical events, layering and associating different

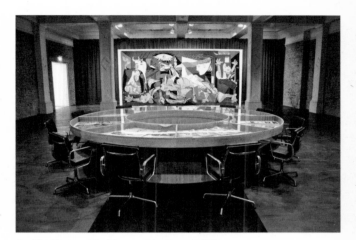

Goshka Macuga, *The Nature of the Beast*, 2009
Installation view, Whitechapel Gallery, London
Courtesy the artist and Whitechapel Gallery Archive

1.
Afghan war rugs began to appear shortly after the Soviet invasion of Afghanistan in 1978. Images of Russian assault rifles Kalashnikovs, hand grenades, armoured fighting vehicles, were woven by women weavers in northern Afghanistan and later by refugees in Peshawar in Pakistan. Others, woven with Iranian techniques, were made in the western Herat area, by Afghan refugees who returned from Iran to Afghanistan.

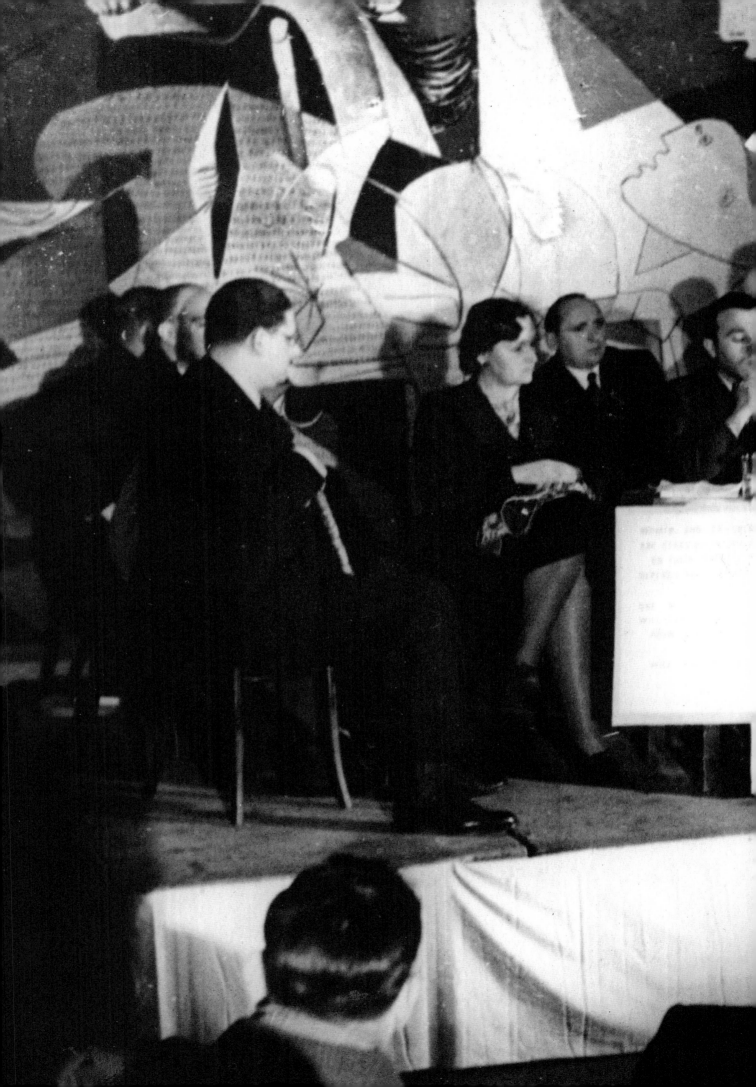

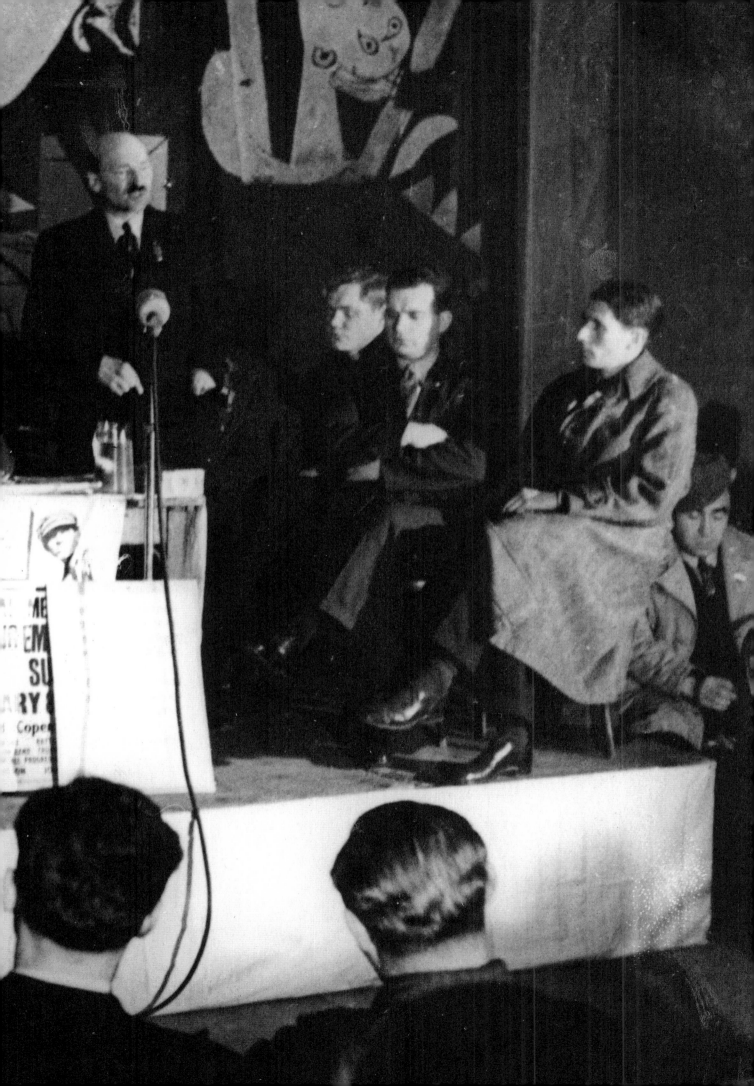

stories, times and places, this network informs an artwork that ultimately evokes the constant recurrence of the inhuman exercise of power in war and the instability of any form of truth.

Traditionally, archives (state archives, libraries, galleries and museums) were organized collections and depositaries of objects, to be preserved for posterity in physical places where first-hand experience and the study of those archived materials was meaningful and reflected the process of formation of culture from the point of view of its commissioning bodies (states and governments, estates, universities and other institutions). Michel Foucault's seminal *The Archeology of Knowledge* (1969), in particular the third chapter 'The Statement and the Archive', reminds us that dispersion and discontinuity characterize all discursive statements: a discourse is an active system of archiving which governs the appearance of statements as historical events, so that any description of a discourse is a form of archeology. An archive, for Foucault, tells us 'what we can no longer say'.

Both of the questions mentioned above – collaboration and the archive – are traversed by the broader (although less discussed) subject of the Internet's impact on how knowledge is produced, accessed and circulated in our world, on how subjectivity is constituted in an endless construction and reconstruction of the self and on how economy, politics, and society generally have been, and continue to be, affected and transformed by the digital.

A part of the project occurred on the Whitechapel Gallery's website, where all the information about the meetings was recorded. Yet Macuga's archive is mainly physical, pre-digital and embodied, even if some of the items in the glass table/vitrine are facsimiles of original documents that could not be borrowed for the display. Compared to some of the massive digital archives that are currently being built online, her display is primitive, humble and small. It is a 'poor archive'. In the course of the exhibition, Macuga collected further material for her archive which was added to the vitrines. It is this open process of accumulation that takes the research in different directions.

Over the past 10 to 15 years, technological devices have constituted 'molecular' networks where people are both more and more connected, yet more and more separated. Access to information is quicker, so more information needs to become available – hence the obsession with scanning as much as possible of our past and present lives. In the digital age, the past haunts us like never before, a potentially inexhaustible repository of traces of history, from which memory (and hence subjectivity) might possibly emerge. A different definition of the archive has therefore developed, according to which an archive is a tagged storage space, a mediated collection of digitalized materials to be experienced second-hand and from anywhere. These digital archives, like Wikipedia or YouTube, are keyed towards increasing access, developing modes of self-regulation and knowledge-sharing. These become, progressively, the expression of a collective subjectivity which is un-authored and shaped by data flows. To build these archives of everything, more and

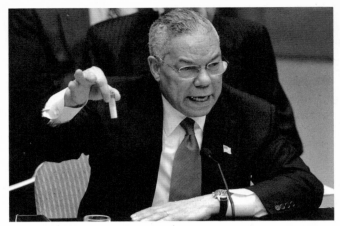

Colin Powell presenting evidence of Iraq's alleged weapons programme to the United Nations Security Council, 2003
Courtesy AP/Press Association Photos

more people must be put to work collaboratively, in an economy that functions on the basis of the products of this immaterial labour. This is our time.

To understand our time, there are conversations to be had with the past, Macuga suggests through her archeological approach, excavating backwards from the effects of war in Afghanistan and Iraq today, and further back, to the Spanish Civil War in the mid-twentieth century. In what appears to be a work about the past, a reading through and a building up of archives concerning specific twentieth-century events, Macuga's project is really a project about our own time, and about our future that is menaced and enigmatic. Just as when Picasso created his famous painting only a few months after the bombing of Guernica, and while the World Fair in Paris in the summer 1937, where it was first shown, seemed blissfully unaware of the incumbent disaster of World War II in a parade of contrasting nationalist self-representations and political ideologies in the different country pavilions, our post 9/11 times seem also unable to fully register, understand and act on the many signs of imminent catastrophe.

History and historical perspectives change, and what was given to us as truth in one moment may, 10 years down the track, be reinterpreted as propaganda, as the story of Colin Powell's speech suggests. With all the imaginable facts before us, we seem nonetheless to know nothing. Unique events, echoed through time by similar events, can however be connected by a storyteller – they become related. As in a dream, they occur synchronically and thus enter into a form of kairological[2] time, where meaning condenses and the instant expands and thickens into consciousness. Authoritarian language is one-directional, it imposes itself. We try to create more equal forms of exchange and conversation, but even those are fraught today, in our times of social networks and what has been called 'knowledge capitalism'. Storytelling is also one-directional, but it openly declares itself to be an interpretation, a negotiation of history, a possibility amongst many. It denies its own factual authority by the very nature of its stated fiction. The exercise in learning how to tell stories – where human actions are repeated yet always different: layered in repetition – is an exercise in the appearance of past

events and their simultaneous disappearance in their projection onto the present. Time becomes mythic time, not linear time, and the ability to tell a story is related to constantly adapting it to the subsequent contexts within which it appears.

Therefore, Macuga's work is not so much a multi-layered, revisited archive on the history of Picasso's *Guernica*, as it is about the possibility and desire to build this archive; it is not so much a space for creating collaborative and collective projects through meetings as it is a space to discuss how and why – and even *if* – collaboration and collective action is possible today. The Picasso narrative tells us that yes, collective political action and activist art achieves results – as demonstrated by the money and boots collected at the Whitechapel Gallery in 1939 in favour of the Republicans in Spain. Nonetheless, the Republicans lost.

However, the presence of a platform where different groups of people could meet, share their views, discuss problems and issues, or elaborate plans of action, was not a 'politically-correct' gesture towards engaged relational art attached to an installation in a gallery. In counterpoint to the apparent heterogeneity of the space of congregation Macuga set up, the platform of enunciations that took place constituted a locus of experimentation of a collective and anonymous murmur – a celebration and a place of enactment of a subjectivity that was both singular and plural, that resisted disembodiment and used fragmentation of the self against that same fragmentation, through the potentiality of provisional aggregations.

In Macuga's web of concurrent, parallel and interconnected stories, three main fields of meaning are interwoven and mutually contaminate each other: the story of *Guernica*, the story of the second Iraq War and Colin Powell's role within it, and the creation of a working space for contemporary collective political action, particularly related to the local sphere of the East End and London. On all three of these levels of meaning – each of which is a constellation – there is a subtle reference to the ways through which truth-value is attributed to events and to the real world and how the criteria for judging truthfulness of any discourse becomes uncertain. On the first level, that of the story of *Guernica*, one wonders if the tapestry which is in front of us is actually a work by Picasso. On the level of the story of Colin Powell and his war speech, one wonders whether it was not his 'trustworthiness' itself that caused the UN to vote in favour of war – had Dick Cheney, a typical 'hawk', given the speech, the outcome might have been different. On the level of the agency in political activism and collective action, the question of how and what can actually happen in this space of corporate-looking chairs, a boardroom-style table, theatrical lighting and a blue curtain is raised. Consequently, the fear that all such spaces of political debate might be equally fraught today cannot be avoided.

Furthermore, between these three levels of meaning, formal associations and slippages occur that interconnect them. A series of linkages and transitive properties are set in motion. The first and the second spheres of meaning fold into each other through the associations

2.
From the Greek *kairos*, meaning destiny, indicating a passage in time that is not linear, nor chronological.

between the Picasso tapestry and the Afghan rug, as well as between Picasso's cubism and the Vorticist style of the Powell bust, and finally, between the inevitable association of the bombing of Guernica and the Fallujah bombings of November 2004, which reduced the city to rubble and caused enormous civilian casualties, through the presumed use of phosphorus bombs (napalm).

Macuga made formal connections in her installation, so that the shape of the archive, its form, also represents the questions and issues addressed within the archive. Slippages between all three levels occur through formal and visual connections, between the round UN Security Council table in New York, the round Calder fountain at the Paris International Exhibition of 1937, and the circular meeting table in the Macuga installation at the Whitechapel Gallery. Oneiric forms of displacement occur in the positions of elements. For example, by placing the Picasso tapestry behind the meeting table, Macuga suggested that this might also be its position in the Security Council. However, at the UN, the tapestry is actually placed outside the Security Council room, where press conferences are held (the tapestry was covered by a blue curtain when Powell addressed the press after his speech in the Council). Behind the Security Council table lies instead a large mural by Per Krohg, donated to the United Nations by the Norwegian Government in 1952, that brings to mind Ambrogio Lorenzetti's fresco *L'Allegoria ed Effetti del Buono e del Cattivo Governo* (Allegory and Effects of a Good and a Bad Government), of 1340,[3] of which the *Effetti del Cattivo Governo*, with its portrayal of ruined and destroyed buildings, may itself have been an influence on Picasso's *Guernica*. In the Security Council room, brown curtains hang to the right and the left of the large mural.

In a further slippage and celebration of the transformative powers of art, Macuga has also created a second tapestry, *On the Nature of the Beast*, which in her installation has now replaced Picasso's *Guernica* tapestry, which was displayed at the Whitechapel Gallery as a temporary loan. In this new tapestry, one sees the artist herself amongst a crowd in the foreground of a room similar to the Whitechapel Gallery, where the *Guernica* tapestry was hung. This tapestry is constructed like a royal court meeting painting. The making of this second tapestry is hinged on a belief in the potential of re-enactment and in the attempt to maintain a form of openness in artistic practice, in the hope that by allowing more layers of meaning to be added, a form of closure can be avoided.

Aware of the provisional, anonymous and often corporate nature of online archives based on word searches, as occurs with Google or other search engines, Macuga's objective, whether conscious or not, lay also in intervening on those platforms, and radically affecting them. Through this project, Macuga contrasted the digital with the embodied, while at the same time interfering in the virtual world of immaterial knowledge organization. At our still embryonic historical stage of the web, indeed, it is possible to re-direct and alter the imaginary constellations to which we are subjected: through *The Nature of the Beast*, the search results for 'Fallujah' and 'United Nations' have been forever altered: through Macuga's project, a huge number of search results now inexorably connect those two together online, and link them to other spheres such as the Guernica bombings and the collapse and recovery of humanity through art. The field of information around these spaces has morphed into a much more complex space of awareness of the contradictions of truth, history, war and humanity.

3.
Painted in Siena's Palazzo Pubblico, this fresco had been created to inspire the city governors to wisdom during meetings held in that room, called the *Sala della Pace* or 'Room of Peace'. Like the UN mural, it is allegorical and shows the consequences and effects of war (bad government) and peace (good government) through a series of scenes.

Cynthia Bronson Altman

Picasso's *Guernica*, and the Tapestry it Inspired

Guernica, the painting

On 26 April 1937, German warplanes bombarded the Basque market town of Guernica, in support of Franco's Nationalist forces during the Spanish Civil War. Almost immediately after learning of the massacre, Picasso began working. Painted as a cry of protest against the horrific bombing of this town, the anguished, writhing figures of *Guernica* have become international symbols of the atrocities of war. Picasso chose this work as his contribution to the Spanish Pavilion of the Paris International Exhibition of 1937. To bring attention to the Spanish Civil War, the artist sent the painting on a journey to Scandinavia and Great Britain during which, in 1939, it was shown at the Whitechapel Gallery. Then Labour Party leader Clement Attlee delivered an address and Picasso requested that the price of admission be a pair of boots, which were then sent to the front for the Spanish Republican loyalists. The painting then travelled to Brazil and throughout the United States – New York, San Francisco, Chicago and Philadelphia – until concerns about its condition finally brought it to rest at the Museum of Modern Art in New York. In 1981 *Guernica* was returned to Spain and hung in the Prado until it was moved to the Museo Reina Sofia. Picasso had said he would sanction its return to Spain when Franco was gone and democratic institutions and public liberties had been restored.

Guernica, the tapestry

René and Jacqueline de la Baume Dürrbach were the master weavers. At their studio in Cavalaire in the Var region in the south of France, they began weaving tapestries after paintings by Léger, Gleizes, Villon, Delaunay and Herbin, as well as their own works. Picasso saw their work in 1951, and in 1955 they wove the first of three tapestries after *Guernica*. It was initially based on a poster from an exhibition in Italy, but in June the painting itself was exhibited at the Museum of Decorative Arts in Paris, where they were able to examine it closely and adjust their cartoon.

> *Each morning, a work session of three hours before the opening of the museum made possible the necessary corrections of the copy of the picture (for the tapestry). The final presentation of the drawing, which has the same dimensions as the paintings, was made at Antibes. Picasso made some corrections, and gave his consent for the weavers to start. The weaving took six months at the Dürrbach studio (J. and R. worked twelve hours a day with unbelievable enthusiasm).*

*The finished tapestry was presented to Picasso,
accompanied by Jacqueline, some Spanish friends,
and the painter Clave ... at the Museum of Antibes,
in November, 1955.*

The weaving was done in eleven colours.

*Variation of borders: the first tapestry has none.
The second has one, in ochre colour, at the request
of Picasso.*

The Contract:

*Here met: M. Picasso, painter, party of the first
part, and M. Dürrbach, master craftsman, party of
the second part:*

1. *M. Dürrbach to weave a tapestry of Picasso's
 Guernica;*
2. *M. Picasso will receive, as author, 10% of the sale
 price of the tapestry;
 M. Dürrbach will receive, for his work and expenses,
 90% of the sale price;*
3. *All the works of Picasso woven by M. Dürrbach will
 be done in three (3) copies;*
4. *It is understood that M. Picasso will receive in
 advance the sum of 10% of each sale.*

*At Vallauris
19 April, 1955
Signed by J. Dürrbach and Picasso.*[1]

Mme J. de la Baume Dürrbach at work in her studio on the tapestry of *The Three Musicians*, 1966

Courtesy Archives municipales de Marseille. Photograph Marcel Coen

1.
Excerpt from a letter to Mrs. Kendall
P. Lutkins, Rockefeller offices,
Picasso tapestry files, NAR Art
files, Rockefeller Archive Center,
1 March 1980.

The Collector, Nelson A. Rockefeller

Nelson A. Rockefeller (1908–1979) was raised among tapestries collected by his father, John D. Rockefeller Jr. This collection included an eighteenth century Gobelin's set depicting the months of the year, and an exquisitely woven set of tapestries from the southern Netherlands depicting the *Hunt of the Unicorn* (*c*.1500). The tapestries hung in their home at 12 West 54th Street in New York from 1922 until 1936 when John D. Rockefeller Jr gave them to the Metropolitan Museum of Art for the opening of the Cloisters in northern Manhattan.

Nelson Rockefeller was an important patron of modern art and involved with the Museum of Modern Art, which his mother, Abby Aldrich Rockefeller, had helped to found in 1929. He wrote of his collecting in 1978:

I was always most strongly drawn to the work of the great European pioneers of modern art, for example, Henri Matisse, Juan Gris, Pablo Picasso, Alexey Jawlensky and Wassily Kandinsky. Their strength in terms of composition and colour was overwhelming. Of all of them, Picasso was always my favourite. His restless vitality and constant search for powerful new forms of expression, combined with his superb craftsmanship and sense of colour and composition, have remained an unending source of joy and satisfaction to me.[2]

Rockefeller had heard of the tapestry after *Guernica* through architect and good friend, Wallace K. Harrison:

I learned from Wally Harrison that a huge tapestry of this painting had been made from a maquette which Picasso had designed after the original painting. The artist himself had chosen the colours of the yarns and supervised the weaving. When I saw the tapestry, I bought it immediately. Alfred Barr (Director of Collections at the Museum of Modern Art, New York) was disturbed by my purchase of what he had heard was just a distorted copy of one of the greatest paintings of the twentieth century; shades of yellow and brown had been introduced into the tapestry, where as the original had been painted exclusively in stark blacks, grays, and whites. However, when Alfred actually saw the tapestry for the first time, he completely changed his mind. He realized that Picasso had created a totally new work of art, designed to be woven as a tapestry. The subject had been sensitively and brilliantly adapted to the different medium, and the result was a stunningly beautiful work of art in its own right.[3]

On 14 April 1955, five days before the agreement between Picasso and the Dürrbachs, Mme Petro van Doesburg, widow of the De Stijl painter Theo van Doesburg, signed a memorandum of agreement as agent for Atelier Dürrbach and Nelson Rockefeller for the weaving of a tapestry after *Guernica*:

1. *The subject matter of the tapestry is to be Pablo Picasso's* Guernica, *now on exhibit at the Museum of Modern Art, in New York. The tapestry is to be approximately 7.72 metres wide and 3.6 metres high, or approximately twenty square metres in all.*
2. *The tapestry is to be woven at the Atelier Dürrbach under the direction and continuing supervision of Pablo Picasso. Atelier Dürrbach will use its best efforts to complete the tapestry within six months of the date of the first payment hereunder.*
 [items 3,4,5 detail issues of cost, shipping and arbitration]
6. *Madame Van Doesburg represents that she has been duly authorized by Atelier Dürrbach to enter into the agreement on its behalf.[4]*

Rockefeller was Governor of New York State from 1959 to 1973. While Governor, one of his missions was to bring the appreciation of modern art to everyone and tapestries were a perfect vehicle for this, as they were bold, striking and easily portable. The Governor's mansion in Albany became an exhibition space for his paintings, sculpture and tapestries including the *Guernica*. In the early 1960s, the *Guernica* tapestry travelled to universities and museums in New York and Maine, and in 1962 and 1963 to four cities in Japan. After his death in 1979, it was exhibited in Denver, Colorado and again in Albany, New York. In 1985 Mrs Nelson Rockefeller lent the tapestry to the United Nations, where it was installed outside the Security Council Chamber. A plaque read: 'In memory of Nelson A. Rockefeller and of his faith in and support for the United Nations.' With renovations to the United Nations Headquarters about to begin the request from the Whitechapel Gallery to display it for a year as part of Goshka Macuga's installation provided a most welcome venue.

2.
Masterpieces of Modern Art, The Nelson A. Rockefeller Collection (New York: Hudson Hills Press, 1981), p.16.

3.
ibid., p.17.

4.
Excerpt from contract, Picasso tapestry files, NAR Art files, Rockefeller Archive Center, 14 April 1955.

The other tapestries

Between 1955 and 1973, 18 images that Nelson Rockefeller thought would work particularly well as tapestries were chosen. The tapestry project gave Rockefeller access to some favourite paintings that were not available to him as they were in museum collections. He wrote on 4 June 1969 to Peggy Guggenheim:

> As you may have already heard, in recent years I have been having tapestries woven after Picasso's paintings as a way of enjoying many of his works which are permanently housed in museums and private collections. One particular painting of his which I have always admired is your Girls with a Toy Boat. I am writing to see if you would consider giving me permission to have this piece made into a tapestry too. Picasso knows of my desire and has agreed to it.[5]

The first two tapestries acquired by Nelson Rockefeller were after two of Picasso's most famous works: *Guernica* and *Les Demoiselles d'Avignon* (1958, MoMA, woven 1958), the third was after *Girl on the Beach* (1960, collection of the artist, woven 1962). Alfred H. Barr Jr, wrote about *Les Demoiselles d'Avignon* on 12 July 1962: 'I looked at it with great interest, though I am inclined to think that paintings like *Guernica*, designed with flat planes rather than with modelled or modulated areas, come off better in this kind of tapestry.'[6]

Rockefeller followed his advice and most of the paintings chosen had simple compositions and broad expanses of colour such as *The Studio* (1927–8, MoMA, woven 1964), *l'Aubade* (1942, Musée National d'Art Moderne, Paris, woven 1969) and *Harlequin*, (1915, MoMA, woven 1968). A pair that echo each other – *Pitcher and Bowl of Fruit* (1931, woven 1970) and *Interior with a Girl Drawing* (1935, woven 1970) – have flat planes of rich, saturated colours and heavy black lines that seem to refer to the leading of stained glass. Two were woven after the murals Picasso completed at the Musée d'Antibes, *La Joie de Vivre* (1946, woven 1970–1), and *Poisson et Cafetière* (1946, woven 1971). These were woven in muted colours: blues, greys and yellows in *La Joie de Vivre*, and greys and whites in *Poisson et Cafetière*.

The tapestry after *Night Fishing at Antibes* (1939, MoMA, woven 1967) was one of the most complex and challenging because of the great number of colours, the variety of brushstrokes and subtlety of modulation; 16 numbered diagrams were prepared by Carol Uht, Rockefeller's curator. She wrote to Mme Van Doesburg on 20 September 1966:

> This work has very few flat areas of one tone. The vigour of the brushwork, as much as any other single characteristic is foremost in this work. To achieve the richness and subtleties caused by the brushwork in the original, I hope Madame de la Baume does not resort to stylized means ... It is the character of Night Fishing, which Governor Rockefeller likes and which we want to recreate in wool.[7]

The final tapestry, the only one woven in silk, was completed in 1975. It was based on *Girl with a Mandolin*, the cubist work of 1910 from Rockefeller's collection, bequeathed to MoMA. The making of the tapestry, completed after Picasso's death, was in negotiation for many years and almost cancelled at one point because of a disagreement about the size. The weavers (and Picasso, according to them) often proposed a larger size than the Governor wished or had space to accommodate.

Today, 15 tapestries are installed at Pocantico, Rockefeller's former home in Tarrytown. Three belong to Rockefeller family members. Nelson Rockefeller's collection of galleries of modern paintings, prints and tapestries and gardens with 80 modern sculptures today are open to the public at Kykuit, a National Trust site 30 miles north of Manhattan in Tarrytown, New York.

5.
Letter, Picasso tapestry files, NAR Art files, Rockefeller Archive Center, 4 June 1969.

6.
Letter, Picasso tapestry files, NAR Art files, Rockefeller Archive Center, 12 July 1962.

7.
Excerpt from letter, Picasso tapestry files, NAR Art files, Rockefeller Archive Center, 20 September 1966.

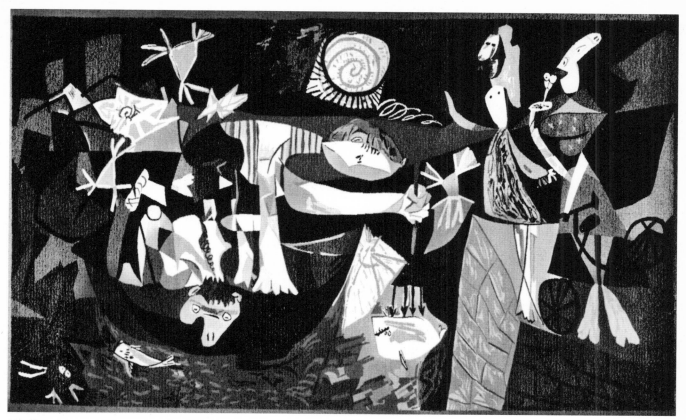

After Picasso, woven by Mme J. de la Baume Dürrbach
Night Fishing at Antibes tapestry, 1967

Collection Kykuit, National Trust site, bequest of Nelson A. Rockefeller

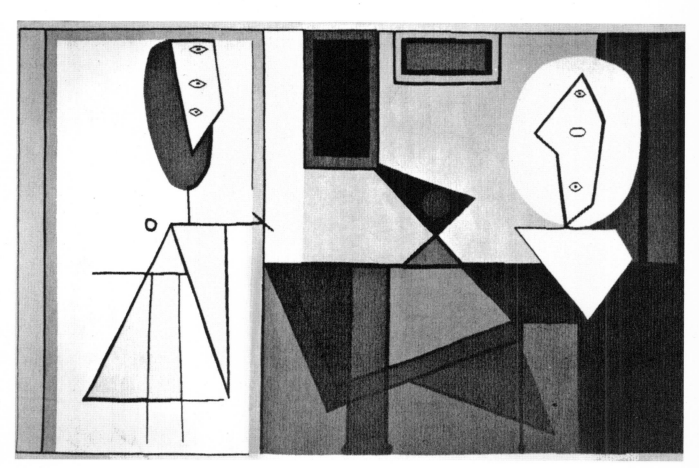

After Picasso, woven by Mme J. de la Baume Dürrbach
The Studio tapestry, 1964

Collection Kykuit, National Trust site, bequest of Nelson A. Rockefeller

Pablo Lafuente

A Picture that Moves: Goshka Macuga's *Guernica*

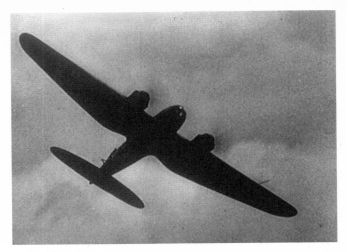

Stills from archival film depicting the bombing of Guernica in 1937

Here was I, trying to make a contemporary political film. But instead of dealing with a present-day theme in 1966, I let the father in the film be a deserter from the Spanish Civil War. What was that a sign of, if not sentimentality? The fear of squarely facing the world as it is today? Exactly![1]

In *I Am Curious (Yellow)*, 1967, a film by Vilgot Sjöman about sex and politics in Sweden in the late 1960s, Spain and its political history feature prominently. For the protagonist, Lena Nyman, the resonance of Spain as a political and ethical standard is equivalent to that of Vietnam, and she uses it to judge her father (who 'chickened out on the Spanish Civil War') and her compatriots (whom she interrogates upon their arrival at Arlanda airport from their holidays in Spain about visiting a fascist state). But, as Sjöman reflected in the diary he wrote during the making of the film, the inclusion of the Spanish Civil War as a political referent in late 1960s Sweden was, at least to a certain extent, a sentimental choice, one that reflected a humanist longing and democratic self-satisfaction. Or what other role could a war that had taken place three decades earlier play within a film dealing with contemporary politics?

The foremost symbol of the Spanish Civil War is, almost without doubt, the bombing of Guernica (or Gernika, in Basque language) on Monday 26 April 1937. This was the first major air raid in Europe targeting a civilian population, and, performed by planes of the German Luftwaffe and the Italian Fascist Aviazione Legionaria, it gave Europeans a picture of things to come. Immediate reports of the events in Guernica were received in the international context first with incredulity and increasingly with horror – a horror that contributed to the moral capital of the Republican regime under attack from Francisco Franco's Nationalist Army, but that didn't make much difference in terms of financial or military support from other European governments. It did, however, turn the city into a universal symbol of suffering.[2]

This symbolic status was certainly reinforced by a painting that Pablo Picasso made between May and June 1937, which, simply titled *Guernica*, was meant as his contribution to the Spanish Pavilion at the International Exhibition that took place in Paris in October 1937. The painting, a 3.5 metre high and 7.8 metre wide black and white canvas, shows a scene of chaos, populated by fragmented and contorted figures of men, women, children and animals (a horse, a bull and a bird) in diverse states of suffering. Despite the referential nature of the title, the abstracted visual language in which the figures and setting are rendered creates a distance from

1.
Vilgot Sjöman, *I Was Curious: Diary of the Making of a Film*, trans. Alan Blair (New York: Grove Press, 1968) p.192. Diary entry from Wednesday, 15 January 1967, titled 'Spain and the Swedish People'.

2.
This universal aspiration was quick to manifest itself, for example in a radio broadcast on 4 May 1937 by Bonifacio Echegaray, member of the Academy for Basque Studies which was titled 'The Universal Signification of Guernica'.

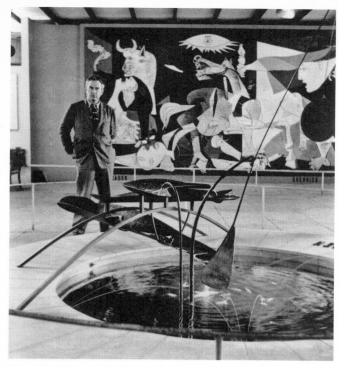

Alexander Calder with his *Mercury Fountain*, Spanish Pavilion,
Paris International Exhibition, 1937

Courtesy Calder Foundation, New York and Art Resource, New York © Calder Foundation,
New York/DACS London 2010. Photograph Hugo Paul Herdeg

3.
Basque painter José María Ucelay,
quoted in Gijs van Hensbergen,
*Guernica: The Biography of a
Twentieth-Century Icon* (London:
Bloomsbury Publishing, 2004),
p.72.

4.
The modernist pavilion designed
by Jose Lluis Sert and Luis Lacasa
also contained works by Joan Miró
and Julio González, as well as
photomurals by Josep Renau. These
formed the visual and conceptual
guide for pavilion visitors. See
Jordana Mendelson, 'Josep Renau
and the 1937 Spanish Pavilion
in Paris', in *Public Photographic
Spaces: Exhibitions on Propaganda,
from Pressa to The Family of Man,
1928–55* (Barcelona: Museu d'Art
Contemporani de Barcelona, 2009),
pp.313–49, p.319.

5.
The painting remained at MoMA
until 1981. On 10 September of
that year the painting returned to
Spain, where it was first housed
at the Casón del Buen Retiro –
an annex to the Prado in Madrid –
and later, from 1992, at the Museo
Reina Sofía, also in Madrid. Picasso,
who had donated the painting to the
Spanish Republic, had requested
it didn't go to Spain while a
dictatorship was in place. He died
in 1973, two years before Franco,
and five years before the democratic
constitution was approved.

6.
See Ronald Paulson,
*Representations of Revolution
(1789–1820)* (New Haven and
London: Yale University Press,
1983), p.17.

7.
The democratic credentials of
the painting were the subject of
a discussion between Herbert Read
and Anthony Blunt in 1938, with
Blunt deeming the painting unable
to appeal to anyone other than
'aesthetes' because of the visual
language employed by Picasso.
See Gijs van Hensbergen, *Guernica*,
op. cit. p.76.

the scene that inspired them. As a result, the painting
can be seen not only as a reflection of the destruction
of Guernica or the effects of the Spanish Civil War,
but as a representation of the destructive potential of
modern warfare and, perhaps even more so, the modern
condition of man.

For a painting that was received upon its unveiling
as 'one of the poorest things ever produced in the world',
as '7 by 3 metres of pornography' with no sense of
composition,[3] a painting that was just a component –
not the most important one – of the pavilion where it
was presented,[4] its current consideration as one of the
key works by Picasso and of the history of modern art
is curious. Also curious is its transformation, from an
instrument of denunciation of the Nationalist uprising,
commissioned as part of a propaganda initiative of the
Spanish Republic, into an autonomous work of art of
universal significance. The fact that the painting was
authored by Picasso, who by that time was already a
celebrated artist, gave *Guernica* the status of an artwork
from the beginning. But its origin as a commission of
the Republic and its first context of presentation gave
this artwork a specific function – a function that got lost
in its ulterior incarnation as a modern artwork. The history
of this loss is also the history of the painting's travels,
from Paris to the Museum of Modern Art in New York,
passing through Scandinavia in 1938, and Britain and
the United States in 1939, as part of a fundraising
initiative for the Spanish Relief Campaign.[5]

That images travel, and that in their travels they might
change their function, is exemplified by the colour red.
In the early years of the French Revolution, the red flag
was a sign of martial law, displayed by the *gendarmerie*
to warn civilians that if they didn't disperse they would
be fired on. But in July 1792 the Jacobin journalist
Jean-Louis Carra printed on the red flag in black letters:
'Martial Law of the Sovereign People Against Rebellion
by the Executive Power'. This bold overprinting made
it the flag of revolution, a status that the colour struggles
to maintain today.[6] Something equivalent happened to
Guernica, with the added complexity that it didn't travel
as a 'mere' image, but as an artwork. Other artworks
have travelled, but not in such a public manner, and this
makes *Guernica*'s itinerary one of its key defining notes.
The attempt to reach an international public through
the transportation of an artwork – especially one of such
size – offers a stark contrast with the mechanisms of
democratization being put into practice by other artists
with leftist aspirations at the time. Frans Masereel's
images of the working class and the new urban
experience were made available through the publication
of his woodcuts within affordable graphic novels – books
without text that offered a visual language of universal
access – but the image Picasso composed for *Guernica*
refused to abandon its material support. This stretched
canvas was unsuitable for such extensive travel. Although
this seems contrary to Masereel's democratizing impulse,
the resistance of *Guernica* to relinquish its painterly
nature, its insistence to be an artwork as well as an
image, ultimately reinforced its status as a painting within
the history of modern art and as an image of the history
of the twentieth century.[7] But an image of what?

For the Basques – or at least for some of them – the painting, like the city of Guernica itself, is a nationalist symbol, one that is employed as an argument in the recurring claims for cultural and historical specificity offering a perfect segueway to Basque demands for reparation, mostly from the Spanish government, for historical wrongs. Guernica and its symbolic tree, the Basque language and Catholicism, the landscape and gastronomy, industrialization, modernism and socialist politics, make up a complex and disputed national image that finds one of its defining notes in the purity of a people who have always been on the side of the oppressed.[8] In this equation, the painting *Guernica* has been, since its arrival in Spain, the object of an ownership dispute – ownership not about the artwork itself but about who has the right to claim the suffering it reflects. A similar dispute about its meaning was provoked by Tony Shafrazi in February 1974 when the member of the Art Workers Coalition spray painted 'KILL LIES ALL' on the canvas as a protest against the war in Vietnam.[9] Shafrazi's statement that his action had resulted in a collaborative work with Picasso called *GUERNICA/MYLAI* claimed the painting as an image of denunciation and propaganda – a reading that the current permanent display at the Museo Reina Sofía also reflects.[10]

The recurrence of these historical conjunctures makes *Guernica* a perfect illustration of James Joyce's 'nightmare of history', the awareness that phenomena of the past are constantly showing through in what is happening now. That this nightmare of history is present in the form of a real nightmare, with fire, death, cries and suffering, is important. The figures in the painting, struggling to keep life itself alive even as they contort in their death throes, offer a portrait of modernity, of the gap between the individual and a constantly changing world that he or she struggles to keep up with.[11] In between the conflicting impulses of construction and destruction that according to philosopher and writer Marshall Berman characterize modernity, men and women, children and animals ... all suffer, although, as suggested by the flower that grows from the hand of the fallen warrior at the centre of the painting, a hope remains. But this is a small hope, and one that is dissociated from agency or any active resistance.[12] The humanist character of *Guernica* (its reflection of suffering rather than rebellion) sits somewhat uncomfortably with the view of the Spanish Civil War as the last romantic war, but is perhaps what has led to the painting's status as one of the key modern artworks, and as one of the key images of modernity.

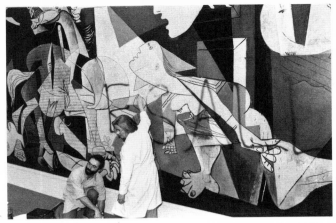

The restoration of *Guernica* at the Museum of Modern Art, New York, 1974
Courtesy AP / Press Association Photos

8.
Bonifacio Echegaray's discourse is a good example of how these ideas found their formulation at the time of the Civil War: 'Our symbolic tree, enshrined in universal literature known the world over represents the love of our people for history and folklore. We are the oldest people in Europe yet we are still a simple people whose minds have not been corroded by power and insolence, who still can respect history and love simple things, from *Guernica* (Madrid: Museo Nacional Centro de Arte Reina Sofía) n.d., n.p. Since the sixteenth century, a tradition has been in place for local representatives to meet in the Guernica assembly under the same family of oak trees. Once the oak dies, one of its descendents is put in its place. The current Basque Parliament, located in Vitoria rather than Guernica, is presided over by a modernist sculpture in oak that resembles a tree, made by artist Nestor Basterretxea.

9.
Shafrazi was protesting against President Richard Nixon's commuting of Lieutenant William Calley's sentence for his part in the My Lai massacre. See Gijs van Hensbergen, *Guernica*, op. cit. p.276.

10.
The current display at Reina Sofía explicitly frames the painting within the Spanish Pavilion.

11.
This reading of the painting and of modernity is Marshall Berman's, in *All That Is Solid Melts into Air* (London and New York: Verso, 1983) p.30.

12.
In fact, agency is completely absent from *Guernica* – the figures only suffer. Because of this, *Guernica* is aligned with Käthe Kollwitz's *War* (*Krieg*) series of woodcuts from 1921–2, images that show the brutality of war inflicted on civilians, not soldiers. When the will to fight is presented, it is, like in *The Volunteers*, as if the men were violently dragged into it, their bodies stretched by the pull of war, while their passion is directed inwards. This absence of agency becomes even more apparent if compared to Hannah Ryggen's *La hora se aproxima* (*The time is coming*, 1938). The almost square, 2 by 2 metre tapestry depicts Franco, covered by a mask, crosses and graves, being fought by the militias of the people, who protect a naked young man symbolizing the vulnerability of Spain and its will to survive. Here, the horrors of the war are present in the suffering of this young, naked man, but resistance is not just the resistance of life refusing to die – it is the resistance of men and women fighting the fascist army. The absence of such imagery has perhaps also been a factor in *Guernica*'s transformation into a universal symbol – its humanism, or what Sjöman would perhaps call its sentimentality.

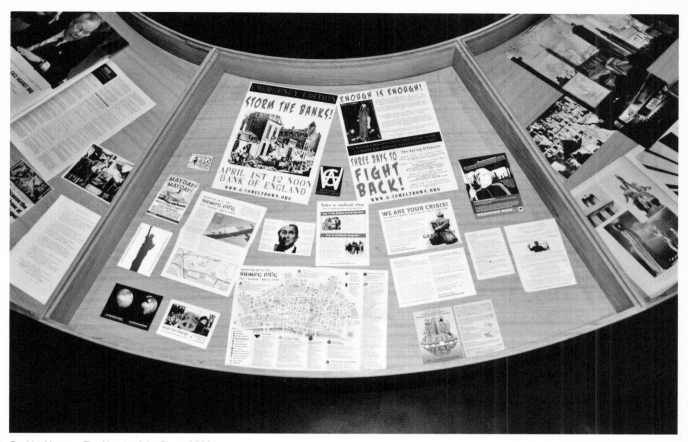

Goshka Macuga, *The Nature of the Beast*, 2009
Installation view, Whitechapel Gallery, London

When Goshka Macuga organized, as part of the project *The Nature of the Beast*, 2009–10, the display at the Whitechapel Gallery of a tapestry version of the painting, made by weaver Jacqueline de la Baume Dürrbach in collaboration with Picasso in 1955, she brought back all these histories – the history of its travels; of the transformation of the image from a political backdrop to a key modern work; the history of the institutions that played a role in the definition of the painting, including the Whitechapel Gallery; and the history of our democracy's engagement with war and liberation. Maybe none of these histories will be apparent when it returns to the United Nations Headquarters in New York, where it is on loan from the Rockefeller Foundation. But another tapestry, commissioned by Macuga as the conclusion of the project, encapsulates all of them. This new tapestry presents *Guernica* once more as a backdrop, this time for an event in which Prince William of Wales, on a podium, is addressing an audience, presumably at the Whitechapel Gallery, which includes Macuga and Iwona Blazwick, the Gallery's Director. In this image, the abstraction of Picasso's language is gone, substituted by an explicit display of the social relations that gave occasion to this new chapter in the painting's travels. The suffering of Picasso's *Guernica* has now vanished, and instead the slightness of institutional politics and culture prevails – in Goshka Macuga's version of *Guernica*, the compositional chaos and pornography that Ucelay identified in the original painting no longer propose a humanist denunciation of the horrors of war, but a poignant reflection of institutional politics and the culture of today.

18th April 1980

Sir Roland Penrose
11a Hornton Street
London W 8

Dear Roland,

Picasso is in everyone's mind at the moment, not simply because of
the large exhibition, but also because so much of his work, especially
the late work, quite suddenly seems particularly relevant for
younger painters. John Walker, for instance, tried depparately to
find a good painting by Picasso to put in our current exhibition.

It occured to me that once Guernica returns from the Museum of
Modern Art to Madrid in a year or so, it will probably not leave
Spain again. And I therefore wondered whether one could not repeat
in part the tour of European capitals that was made in 1937/38 and
which London involved showing the paintings both in the West End
and, of course, at the Whitechapel. I know that Joanna is trying
to arrange for part of the Paris show to come to the Hayward in the
Summer of 1981, but this would be quite different and of extraordinary
interest to a great many people.

I shall be in New York at the time of the opening of their show and
will raise the idea with William Rubin. If you think the idea is a
good one, perhaps you could suggest anyone else with whom you think
I should be in contact.

I am glad to hear that your exhibition will be shown at the ICA.

Yours sincerely,

Nicholas Serota

(Dictated by Mr Serota and signed in his absence).

Nayia Yiakoumaki

The Nature of Archives and *The Nature of the Beast*

Goshka Macuga's practice revolves around the archive, she focuses on these repositories of information, frequently utilising their material in her resulting projects. Concerned with revealing unknown or latent associations between people and events, Macuga instinctively lifts the drape which covers historical facts in order to see what lies behind. Interested in configurations that shape the perception of the world surrounding us, her installations become melting pots for very different states of affairs, which she extracts across history and across archives. The finished installations consist equally of excavations and constructions which interrelate, almost concurrently during the connection of what, in most cases, are seemingly unrelated historical facts as seen in the first Bloomberg Commission at the Whitechapel Gallery.

Without doubt *The Nature of the Beast* conveyed a symbolic act; bringing the *Guernica* tapestry from the United Nations building in New York to the Whitechapel Gallery in London was equivalent to making it accessible again, revealing it; a direct commentary on the covering of the tapestry in 2003 and a direct renouncement of censorship, misinformation and the media's manipulation of the information we receive.[1] It was also a significant act for the Whitechapel Gallery's history. 80 years after its first display in 1939, *Guernica* (not the painting but its effigy) finally returned to the Gallery to launch the redevelopment in April 2009. A glorious return journey that the original painting never achieved.

So what does it mean to curate from a century-old archive, using it as the primary research source for artists, and in this case Macuga's commission? Archives interpret the notions of history, fact and discovery, providing the ideal background for projects aiming at the reinterpretation of their material. The similarities in the process deployed by a curator and an artist alike resemble the historian's processes in the archive. They are fundamentally interrelated and can be seen as an application of the three main 'constituents of historiography', profoundly analysed by the French philosopher Paul Ricoeur in *Memory, History, Forgetting*.[2] Curator's and artist's methodologies become a historiographical operation. Briefly, Ricoeur stated that there is no uniquely privileged model for historical accounts; the historian must be attentive to the multiple meanings that make action intelligible. Curatorial and art practices drawn from, or born within, the archive find an important analogy in this idea; the curator and artist locate, read, interpret and finally use archival material to produce an art project which will also become, in some cases, archived. This condition brings them in parallel with historians as users and interpreters of the archive,

Installation of Goshka Macuga's *The Nature of the Beast*, 2009
Whitechapel Gallery, London
Courtesy the artist and Whitechapel Gallery Archive

1.
When in 2003 Colin Powell, John Negroponte and Hans Blix from George W. Bush's administration held press conferences at the United Nations Headquarters about the American intervention in Afghanistan and Iraq, a blue curtain was hung over the tapestry. This action resulted in a public outcry and the incident was extensively covered by the press.

2.
This operation comprises three distinct but inseparable constituents, all of which are interpretative activities: The Documentary Phase, Explanation/Understanding and The Historian's Representation. These stages are employed by Ricoeur to describe the historian's process but do not apply exclusively to just this group; to a greater or lesser extent they apply to all users of the archive, including curators and artists, and are fundamental processes that occur each time we visit, read and interpret archive material. See Paul Ricoeur, *Memory, History, Forgetting*, trans. by Kathleen Blamey and David Pellauer (Chicago and London: University of Chicago Press, 2004). For an in-depth analysis of the association of curating archives and historiography, see Nayia Yiakoumaki, *Curating Archives, Archiving Curating*, doctoral thesis (London: Creative Curating, Department of Visual Arts, Goldsmiths College, University of London, 2010).

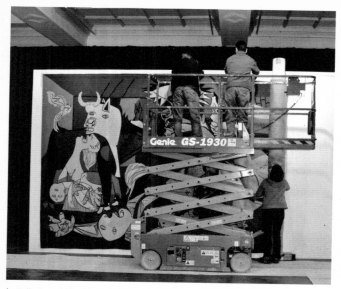

Installation of Goshka Macuga's *The Nature of the Beast*, 2009
Whitechapel Gallery, London
Courtesy the artist and Whitechapel Gallery Archive

but also as producers of historical/art-historical accounts. These steps of historiography are the backbone of Macuga's engagement with the archive and her involvement with it leaves a trace in the Whitechapel Gallery Archive and will potentially become an impetus for further contemplation. This process demonstrates the complexity and richness of the historiographical operation and solidifies the practice of curating from archives and the practice of art-making as a path for the research, explanation and reinterpretation of history.

Although every archive is subject to an accumulative process and each curator, archivist or researcher alters it by providing another interpretation, it is only the artist who is granted carte blanche to intervene and alter the archive; a license that neither the curator, the archivist nor the researcher possess. The artist functions according to a different process which takes the archive as material but does not need to abide by its formal and structural formation. Macuga's methodology is effective because she remains faithful to the historicity of the documents, but at the same time is not intimidated by their aura and so she alters them;[3] she overcomes the constraints inherent in archives (to constantly preserve) by manipulating (physically and conceptually), not of course the original but a replica of the original, and consequently, re-deposits it in the archive. This is the stage that Jacques Derrida described in *Archive Fever* as the augmentation of the archive; the precise point at which a new idea is deposited in the archive and as it enhances it, it also permanently alters it.

The Nature of the Beast has been documented at all its stages of development; from the initial meetings with the artist and the curatorial team to the structure of the installation. The research process itself has been tracked and records of all correspondence and research links have been kept. The round table meetings have been recorded in audio and/or video, and have contributed to the main installation as well as having fed into another small exhibition based on the new archive material that has been acquired. The archivization of

the whole project will be deposited as a sub-archive in the Whitechapel Gallery Archive. The independent *The Nature of the Beast* archive which was derived from a curatorial imperative will become a significant resource for future researchers. They will not only have the opportunity to view the individual archive material but will come across the ideas this material has generated and the events it has instigated. *The Nature of the Beast* provided the impetus for numerous public responses; through interlinking the relevant Picasso files held in the Gallery's archive (1939, 1952, 1981) without being restricted by it, it has further unpacked the social, political and artistic significance of *Guernica*'s display in the East End in 1939.

The Nature of the Beast is presented here as a project that raises issues around curating, historiography and the notional expansion of archives. As a commission it provides an ideal model for curators and artists to work together with an archive. It not only demonstrates a deep engagement with historical material, but also shows that the outcomes of the project are crucial to the making and development of the archive in question. Moreover, it has cemented the Gallery's century-old archive as a fertile field for continuing intellectual and artistic debate.

3.
See Goshka Macuga, *Objects in Relation*, 2007, Tate Britain, London.

15th May 1980

Sir Roland Penrose
11a Hornton Street
London W 8

Dear Sir Roland,

Thank you for your note about Guernica. Margaret McLeod was in
Madrid last week, making arrangements for the forthcoming Henry
Moore exhibition, and she discussed the question on our behalf
with the man responsible for the return of Guernica to Spain.
Unfortunately he confirmed that the painting is extraordinary
fragile and that they would not be prepared to lead it travel
anywhere either between New York and Spain, or even afterwards.
However, my disappointment is tempered by hearing that Joanna
has almost obtained final agreement for a major showing of the
estate at the Hayward next summer.

With best wishes,

Yours,

Nicholas Serota

(Signed in Mr Serota's absence)

Sally O'Reilly

Public Debate Roundly Discussed

The legendary round table at the court of King Arthur was well ahead of its time as a tool for modern democracy in a feudal era. A round table has no head and therefore promotes no hierarchy of power; and it was hoped that this democratizing quality would stem the quarrelling of the court's attendant knights. Questions as to the veracity of the legend aside, we might look sceptically upon the democratic nature of the round table itself. Our contemporary experience of wedding banquets, for example, demonstrates that sitting at one of the convivial round tables is the result of hidden processes of judgement and categorization. As *The Round Table –* the journal of the British Commonwealth – more gravely exemplifies, presence at the round table is evidence of an inside and an outside; it is symptomatic of authority held rather than power distributed.

The round table devised by Goshka Macuga to augment and extend ideas articulated by Picasso's *Guernica* aimed to eradicate sublimated authoritarian control. Just who sat at this table was decided by neither the artist nor the Gallery, but was determined through the simple act of expressing a desire to do so. Through announcements in the Gallery's customary print and email marketing it was made known that the table could be booked for meetings. Provided that there was no clash with a previous booking, the table was available to anyone with any agenda to discuss anything, in whichever way they wished, in the public space of the Gallery. Of course, the Whitechapel Gallery being what it is, it was unlikely to attract groups with unsavoury, incorrect or too challenging an ideology or message; but still, this is an uncharacteristically unstructured way for a public institution to conduct onsite activities.

Throughout the year the table hosted meetings, seminars, discussions, readings, lectures and performances that ranged from the highly pragmatic

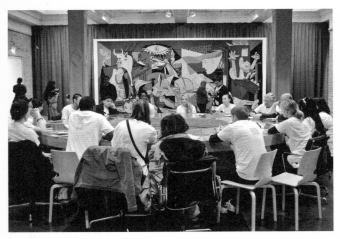

A class from the University of East London debate the theme of 'Confession'
Courtesy Whitechapel Gallery Archive. Photograph Raymond Yau

and instrumental to the abstract and theoretical. For example, a number of schools in the borough used the table as a place to cement methods of electronic logging of homework records among teachers, as well as a forum in which to open up the world of history and conflict for pupils. Groups with a wide range of affiliations, from the radical to the hobbyist, would conduct meetings outside of their customary venue, while in other instances individuals came together for the first time to negotiate new ideas and propositions. VHS video basement – a group that establish 'a makeshift self-propelled incessant cinema of desire' that runs counter to the stale and formulaic mainstream film industry – sat informally on the floor, asking fundamental questions about how to run a space, such as how to differentiate between visible self-organization and commercial self-promotion. The meeting held by Toastmasters International, on the other hand, would have been a very different affair altogether; their workshop on how to conduct public speaking with conviction necessarily dispensing with any trace of uncertainty and the table becoming the perfect prop of authority. As a member of the *Prospect Magazine* reading group commented 'At first we were quite intimidated by the echoing acoustics, the fact and number of observers and the sheer size of the table, which was meant to evoke the UN Security Council'. It is difficult, it seems, to shake off the atavistic allusions to power of such ceremonial furniture.

It is a sign of the times, perhaps, that when the public feel at a remove from the operations of power at national and international levels, they group and regroup at the level of the local. The historical gravity of the meeting table provided groups and individuals with a means by which to invest collective, desire-driven ideology or singular subjective exploration with an appropriate rationalist and authoritative framework. Concerns were considered from the viewpoint of the very particular to that of vertiginous universals. The Forum for Green Theology, who used their session to discuss the theological perspective on climate change and how faith affects environmentalist thinking and action, seem a universe away from the schoolteachers who are dealing with matters of day-to-day organization.

A major feature of the contemporary political landscape is the conundrum of how to integrate the individual and society, given the ground swell of neo-liberalism that encourages us to prioritize our own needs and desires. The free market, the entrepreneurial self, the rights of the individual have, it is claimed, almost entirely displaced our sense of social responsibility and public accountability. Whereas in the past idealistically imbued models of the future transcended the parameters of the individual through collectivity and a scope that was pitched to include generations to come, in a sceptical society that supposedly no longer believes that ideologies are sustainable, this long-range thinking has been replaced with bald ambition on a personal scale. The public sphere becomes privatized and depoliticized and parliamentary politics is devitalized through the absurd public spectacle of party wranglings. In a discussion organized by The Royal Society of the Arts between Jeremy Deller, Gustav Metzger, Cornelia

Parker and Emma Ridgeway the image of the artist as lone genius is roundly trounced and replaced with one of individuals that acknowledge the influence of wider society, even if only in regards to the art market through which they become powerful, socialized and instrumental. This new constitution of the solo artist, they suggest, is becoming unfashionable and untenable. The question remains, however, of how to construct meaningful models of critical discourse, collective deliberation and social change that preserve the democratic imperatives of public life.

One answer is manifest by the political subculture of direct action, where issues are lobbied for and against by forceful pressure groups and courageous individuals. But while this gives voice to non-compliant views, it also recasts the politicized as an atomized and instrumentalized entrepreneurial figure that, like their complicit capitalist counterpart, considers palpable effectiveness as the goal rather than a subtler force within the complex fields of history, culture and society in general. When access and transparency are achieved in a single moment of self-exhibition and declaration, this can be more individuating than binding. The activities spurred by *The Nature of the Beast* relate a different approach, whereby openness and collectivity is lower key, ongoing and sustainable. In the aforementioned RSA discussion the speakers approached just such an issue in relation to climate change. In contrast to what one of the speakers described as the 'dreadful public art about climate change' that can be seen to be springing up in response to certain commissions, the group put forward the proposition that to paint the top of all buildings white – a strategy suggested by scientists to reflect back the heat of the sun – could be extended into a creative venture. To wear white hats, glaze the top of cars and find manufacturing solutions that would change the visual as well as ecological landscape is a performative gesture that would require us all to participate.

The Spanish Civil War, which Picasso's *Guernica* memorializes, was notoriously complex in its constitution, with political factions appearing to strike alliances that confused such basic polarities as left and right, centralists and regionalists, authoritarian and libertarian. The war demonstrated how apparently rival groups often converge at unexpected points, suggesting that factions are rarely predictable or ideologies fixed. The documentation of the events that took place during *The Nature of the Beast* can similarly be seen to be fragmentary, at times self-contradictory and resolutely unresolved. What transpired around the table was not so much the offering up of internal workings for public scrutiny, but the temporary and partial visibility of methods of discourse. Indeed, we should not necessarily demand that all that was previously hidden is now apparent, as privacy has a place in the democratic process despite regular calls for the opposite.

The private was once thought of in terms of privation, the lack of attention or socializing opportunities. In contemporary experience and parlance privacy relates to interiority, whether that pertains to the social body (members only), the visceral body (private parts) or anti-socializing architecture (behind partitions). The private carries associations of secrecy, intimacy, isolation, solitude and taboo and this, in turn, has been critically interpreted as delineating orthodoxies of power, such as private property and the atomic family, while marking the limit of democratic collectivity and hindering expansive notions of the greater social good. The private realm is deemed to provide a reprieve from public judgement and justice, and this would be where the unjust, deviant or unseemly loiter. But then again, the public declaration of one's intentions can be interpreted as an act of aggressive authenticity, even though we all recognize that within our sense of self the authentic is often difficult to pin down. The private recesses of the human mind and the social body are mysterious and complex, and the nature of the beast is generally to obfuscate, hide, self-protect. An admirable aim might be to square this with calls for clarity, rationalism and readability, to reach a viable and valuable balance between the sociable and the intimate human.

Dear Visitor,

This exhibition revolves around the presentation of
Picasso's original painting, 'Guernica', at the Whitechapel
Gallery in 1939 and the placement and role of the tapestry
at the United Nations Headquarters in New York from
1985 to 2009. In both instances, the image has been
used as a backdrop for political debate.

The room has been designed with a real emphasis on
accommodating and encouraging meetings for discussion
groups, with 'Guernica' used once again as a backdrop. You
are therefore invited to host meetings and discussions
around the central table.

The space is offered free of charge. Contact
guernica@whitechapelgallery.org for advance booking.
We only ask that you send photographs, recordings or
minutes of your meetings to this address for inclusion
in the gallery's growing archive.

Many thanks,

Goshka Macuga

Meetings'
Archive

02.04.2009
Inaugural Meeting

08.04.2009
Arts Council England
Visual Arts Team

17.04.2009
Cass Business School

Timed to coincide with the G20 meeting in London, a range of speakers were invited to participate in an informal round table discussion responding to the current political and economic climate. This gathering started the public meetings programme within *The Nature of the Beast*.

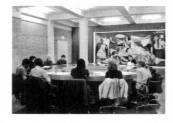

The Visual Arts Team, London Office, Arts Council England, held their regular team meeting around the central table.

Senior Lecturer Clive Holtham brought The Business Mystery MBA course to discuss *Guernica*, the Geneva Convention and creative problem solving through art.

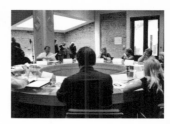

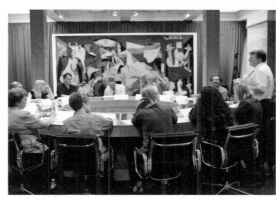

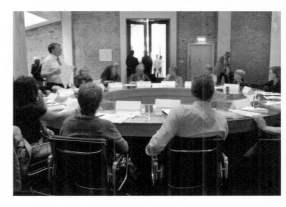

FREEDOM

80p www.freedompress.org.uk Vol 70 No 08 • 25 APRIL 2009

FACTORY OCCUPATION

The workers at Visteon take on Ford

At the time of going to press, workers at the Visteon factory in Belfast are in their fourth week of occupation, despite being threatened with eviction. Fellow workers at Enfield and Basildon are on a continuous 24-hour a day picket as part of a co-ordinated campaign of direct action against the company sacking its entire UK workforce without pay, notice or redundancy.

When Visteon UK Ltd, who manufactures specialised car parts for Ford, closed its three factories in Belfast, Basildon and Enfield following years of reported mounting financial losses, 565 jobs were lost. Occupations began on 31st March when workers were told, without prior warning or consultation, to collect their belongings and leave after administrators confirmed the company was ceasing operations. Belfast workers immediately took occupation and refused to leave. Basildon workers, who were given just five minutes notice, were forced out by heavy-handed police threats of violence and intimidation. Workers at Enfield, having already been locked out, occupied the following day when they returned to clear their lockers.

page 3 ▶▶

LENS CAP BRIGHTON

For those going down to the south coast for the Mayday weekend, here's a picture of a typical Brighton squat you may consider staying in. Don't leave the lights on like these folk did, because it's bad for the environment and we don't want you arrested for abstracting electricity.

BEANO TO BRIGHTON

Mayday greetings to all of our readers

It's Mayday again Comrades! How quickly Anarchist Christmas comes around! And lucky you! In this issue we feature in depth biographies of all the Haymarket Martyrs and astounding new forensic evidence that clears up once and for all who fired the fatal bullets in the aftermath of the 1886 Chicago explosion. Or not.

Actually we focus on the rise in workplace and community struggles and analyse the crisis in public order policing in the aftermath of the G20.

However all social contestation and no play makes Jackie a dull revolutionary, so we recommend a trip to the seaside.

On page 2 we have the latest on the Smash EDO MBM/ITT campaign from our Brighton comrades, together with a warm invitation to visit their fair city for a weekend anti-militarism conference on 2nd and 3rd May, and a street party on Monday 4th May starting at 12 noon (dress code wear red, for more details see smashedo.org.uk or call 07983084019). So get your bucket and spade and head for the beach.

We hope to report lots of jolly things from events around the world in our next edition and, in the meantime, whatever you're doing we wish all our readers a merry Mayday, be safe but have fun.

INSIDE ▶▶

ISSN 0016-0504

23.04.2009
Glovebox

23.04.2009
G20 Meltdown

24.04.2009
Open Convention

30.04.2009
University of Hertfordshire

The art blog *Glovebox* held a planning meeting to discuss their forthcoming change in format to an online magazine.

A meeting organized by Simon Wells of various groups involved in G20 Meltdown, an anti-capitalist protest held on 1 April.

Richard Naylor read the paper 'The Artifactual Aftermath of Wars and What Can We Do With It?' and chaired a brief dissection of the text. After the discussion, he and one attendee agreed to ask Whitechapel Gallery to collect one million pounds in donations for the relatives of genocide victims.

University of Hertfordshire BA (Hons) Interior & Spatial Design Year 2 students met with Senior Lecturer, Heidi Saarinen, to discuss 'Performance East', a new design project based on spatial analytic choreography with Gallery 2 as the project site. During the meeting, there was a lecture titled 'Spatial Choreographies' followed by discussion. The students also performed short improvised choreographies.

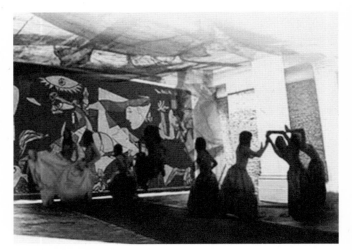

06.05.2009
Public Health Department
NHS Tower Hamlets

13.05.2009
University of East London

14.05.2009
London College of
Communication

21.05.2009
Prospect Magazine
Reading Group

The Public Health Department, Tower Hamlets, used the appropriately public space to hold their team meeting.

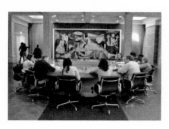

Si Sapsford and Faisal Abdu'Allah brought their first year seminar class for a group debate on the theme of 'Confession'.

Artist Carey Young held an MA photography seminar in which students responded to *The Nature of the Beast*.

A reading group from the political and cultural periodical *Prospect* analysed the book *Guernica: The Biography of a Twentieth-Century Icon* by Gijs van Hensbergen.

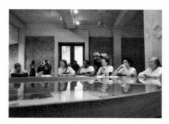

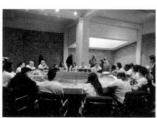

27.05.2009
Minority Rights Group
International

29.05.2009
Cass Business School

02.06.2009
Welling School

03.06.2009
University of the Arts London

Journalist and author Mark Lattimer gave a lecture entitled 'From Guernica to Gaza. Picasso, the Geneva Conventions and Death from the Air'. The event was organized by members of MRGI, a non-governmental organization working to promote the rights of minorities and indigenous peoples worldwide.

Senior Lecturer Clive Holtham returned (having previously used the space on 17 April) with The Business Mystery MBA course to discuss *Guernica*, the Geneva Conference and creative problem solving through art.

Teachers Phil Scott and Tamsin Wildy facilitated a group critique of year 10 students' coursework based on the theme of 'Change'.

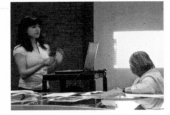

Uncharted Stories, an interdisciplinary research forum and curatorial group from University of the Arts London discussed the planning of their future exhibition.

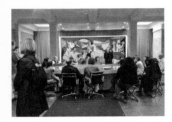

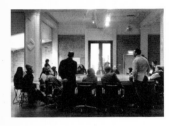

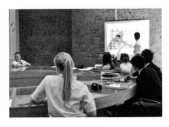

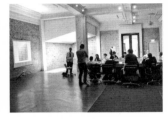

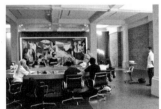

04.06.2009	05.06.2009	05.06.2009	10.06.2009
Welling School	Hampton School Art Department	Royal Society of Arts: Arts and Ecology	British Interactive Media Association

A group of teachers from this specialist visual arts college held a departmental meeting.

Teachers from Hampton School Art Department held their regular departmental meeting at the table.

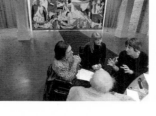
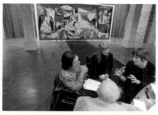

Curator Emma Ridgway of the RSA Arts & Ecology Centre held an informal salon event titled 'Environmental Change' with artists Jeremy Deller, Cornelia Parker and Gustav Metzger. The meeting took place on the occasion of the UN World Environment Day and focused on artists addressing issues of environmental change.

The BIMA held a planning meeting regarding their joint initiative with the University of East London's 'The Creative Way'. The discussion generated proposals for a series of events entitled 'Meet the Professionals' in which students from the Thames Gateway region could meet people working in the digital media industry.

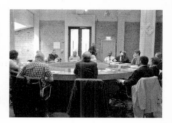

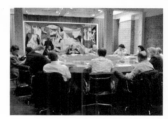

Socially conscious film group Cinemitic met to discuss the future plans for their fundraising activity.

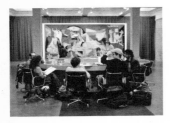

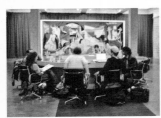

A group of media artists held a planning committee meeting to develop ideas for their Biennial Festival of Media Arts due to begin in March 2010.

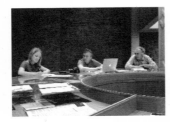

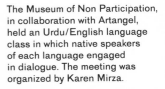

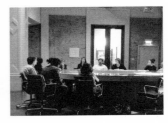

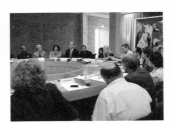

Iwona Blazwick, Whitechapel Gallery Director, chairs the London Cultural Strategy Group, a high-level advocacy group that aims to develop and promote London as a world-class city of culture. The primary role of the group is to advise the Mayor of London on his cultural strategy and to present in a unified voice the ongoing challenges and needs of the sector. The group held their regular meeting around the central table.

The Museum of Non Participation, in collaboration with Artangel, held an Urdu/English language class in which native speakers of each language engaged in dialogue. The meeting was organized by Karen Mirza.

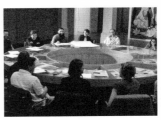

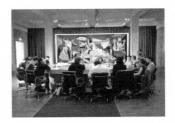

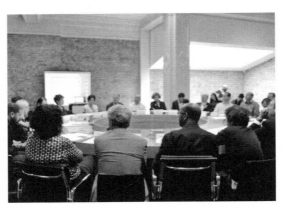

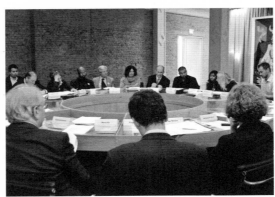

19.06.2009
Godolphin & Latymer Schools

24.06.2009
Format Artists Discussion Group

25.06.2009
Columbia Primary School

04.07.2009
The International Brigade
Memorial Trust

UVI español tarde de despedida, 19 de junio 2009

Emily Allen-Mersh
Marina Bunzl
Jaya Campbell
Maria Tsitsopoulos
Annabelle Acton-Bond
Chloe Bustin
Georgina Haris
Willow Murphy
Lexi Wells
Tessa Bonduelle
Camilla Buyer
Chloe Burrows
Isobel Duncan
Ari Dwyer
Gigi Gaunt
Tally Shively
Margaux Simon
Tamar Gottesman
Amanda Salvest
Claire Vezie

Spanish language students
met to discuss the effects
of war on art and the imagery
in Picasso's *Guernica*.

The Format Video and
Photography Network met to
debate the social relevance
of artistic practice.

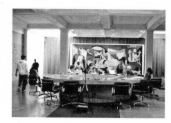

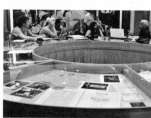

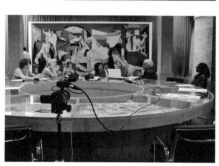

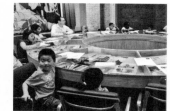

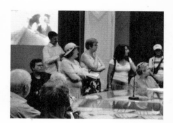

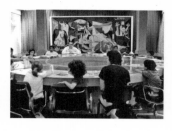

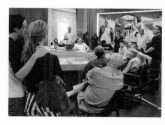

The Columbia Primary School
Council met to deal with
issues raised by class council
representatives.

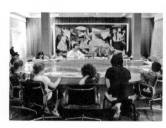

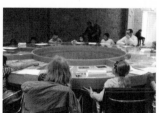

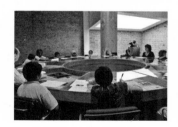

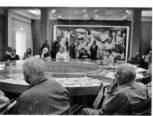

Members of the International
Brigade Memorial Trust held
an event to commemorate those
who fought for the Republican
cause during the 1936–9 Spanish
Civil War. Accompanied by live
Spanish music, a discussion took
place on the impact of the original
Whitechapel Gallery exhibition
of Picasso's *Guernica* in 1939.

BOOKING FORM
The Bloomberg Commission: The Nature of the Beast: Goshka Macuga
5 April 2009 – 18 April 2010
Gallery 2

Thank you for choosing to hold your meeting at the table in *The Nature of the Beast*. Please complete this booking form prior to your visit so that we will be better able to accommodate you. This information will also be used to create an archive documenting the exhibition and it may be included on the gallery's website, in promotional material and future publications by the Whitechapel Gallery and Goshka Macuga.

1. What is the name and focus of your group? *The Godolphin and Latymer School UVI Spanish A2 and IB group*

2. Does your group have a website or blog? (If yes, please list) *WWW. the godolphin and latymer school. com*

3. What is the nature of your meeting? *To discuss the effects of war on art and the imagery in Picasso's Guernica*

4. Does your meeting have a title? (If yes, please list). *No*

5. What are your preferred dates and times? *Friday 18 June 4pm – 5pm*

6. Please list any special requirements you may have. *None*

7. How many people will attend the meeting? *20 students + 4 staff*

8. Please list the names of everyone who will attend the meeting. *On separate sheet*

9. We ask that all meetings be documented by you in the format of your choice (e.g. video, photo, sound, text). Please confirm that all invited attendees agree to let their images and voices be used in the Whitechapel Gallery archive, website and future publications. *yes*

10. It is possible to promote your event by having us list it on our website. Please indicate if you wish this to happen. *No*

11. Who is the contact person for the event (someone from your group that we may contact in case of any last minute changes or questions)?

Name: *Rachel HART*
Mobile: *07812 024356*
Signature: *RHart*

Please review the exhibition guidelines before your visit. We're very happy to collect any more information that you would like to provide us with about your group, during or after your meeting. For more information about the Commission please visit: www.whitechapelgallery.org/exhibitions/the-bloomberg-commission-goshka-macuga-the-nature-of-the-beast

06.07.2009
MLA London

09.07.2009
we20

10.07.2009
Shoot Experience

12.07.2009
Survivors Fund

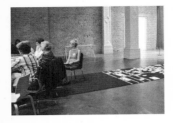

Museums, Libraries and Archives London held a planning meeting regarding the future of their Knowledge Transfer Innovation Fund.

we20.org allows citizens to shape and inform policy, action and business through their own G20 meetings. we20 launched at the G20 Summit in London and is building a platform to allow bottom up participation in the process of finding solutions for 21st-century local, national and global challenges. we20 held a summit titled 'Use of Empty Shops' to discuss the use of empty shops as platforms for events.

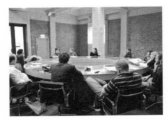

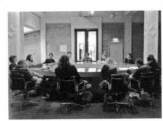

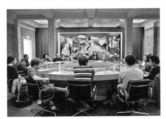

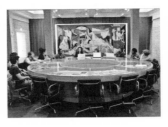

Shoot Experience, an experiential photography organization, met to discuss the editorial options for their new photo-library Shoot Bank.

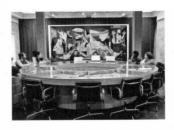

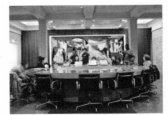

To mark the end of the 15th Anniversary of the Rwandan genocide, Survivors Fund (SURF), a London-based international organization representing and supporting survivors of the Rwandan genocide, met to read the testimonies of survivors in Rwanda. Supporters of SURF, as well as members of the public, were invited to read a testimony.

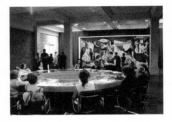

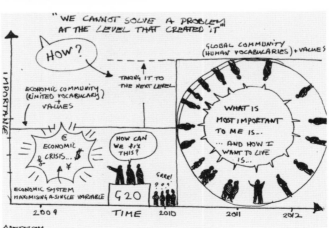

17.07.2009
Enemies of Good Art

22.07.2009
Central Saint Martins

23.07.2009
University of the Arts London

23.07.2009
Campaign for Real Democracy

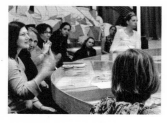

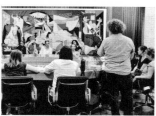

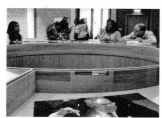

Uncharted Stories, a curatorial group of research students from University of the Arts London held a second meeting to discuss the planning of their future exhibition.

Organizer Mark Barrett of Campaign for Real Democracy invited localists and various community representatives to engage in a dialogue over the initiation of a Localists' Democracy Union.

Taking as a starting point Cyril Connolly's idea that 'there is no more sombre enemy of good art than the pram in the hall', artist Martina Mullaney organized a debate on the parallel roles of artist and mother. The Meeting was chaired by Jennifer Thatcher, writer and critic and then Director of Talks at the ICA.

Artist Nicola Berry staged a site specific performance followed by a discussion on contemporary art with BA Fine Art students at Central Saint Martins.

Exoticos — Mexican Gay Wrestlers, 2009
**Marcela Montoya-Turnill
& Cayetano H. Rios**

UN CHARTED STORIES

CCW
Camberwell Chelsea Wimbledon

Graduate School Launch Festival
The Triangle Space @ Chelsea School of Art & Design
28 October → 5 November 2009

Private view
6 pm → 9 pm, 28 October
11 am → 6 pm daily or by appointment, except Sunday

www.unchartedstories.wordpress.com
www.arts.ac.uk/research

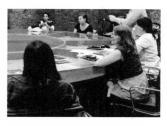

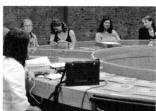

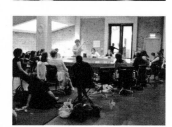

Disruptive identities and cultural continuities, 2009
Pedro Carvalho de Almeida

UN CHARTED STORIES

CCW
Camberwell Chelsea Wimbledon

Graduate School Launch Festival
The Triangle Space @ Chelsea School of Art & Design
28 October → 5 November 2009

Private view
6 pm → 9 pm, 28 October
11 am → 6 pm daily or by appointment, except Sunday

www.unchartedstories.wordpress.com
www.arts.ac.uk/research

25.07.2009
SpRoUt

29.07.2009
University of Pennsylvania

30.07.2009
Young Curators

30.07.2009
Not in Our Name

The SpRoUt artist collective met to discuss their forthcoming project: 'Under Construction II. They Will Have Gathered', scheduled to take place in Zagreb in September 2010. The dialogue was organized around the idea of a verbal relay race where ideas were passed around the table from one person to the next, being mutated and renewed as they went. The discussion revealed differing perspectives and divergent ambitions within the group, leading to a moment of crisis and then a reinvention of the collective, its aims and its membership. SpRoUt currently has four core members who are working on a new website and 'Under Construction II' – an alternative art school project.

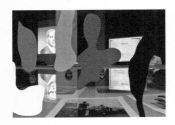

American students from the Department of English, University of Pennsylvania, discussed William Blake's poetry and Zadie Smith's novel, *White Teeth*. The discussions were part of two literature seminars led by Professor Chi-ming Yang: '18th-Century British Poetry' and 'London in Fiction and Film'.

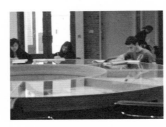

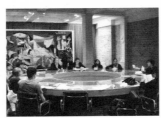

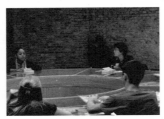

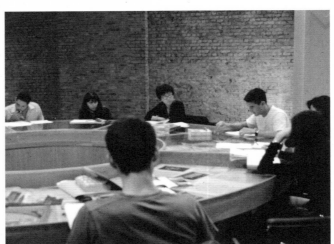

The first participants of the Whitechapel Gallery's Young Curators scheme gathered with artist Faisal Abdu'Allah to evaluate their debut exhibition.

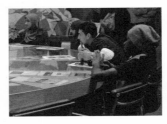

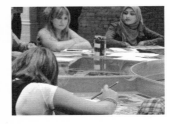

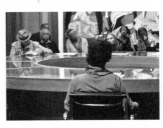

Independent filmmakers Hazuan Hashim and Phil Maxwell screened *Not in Our Name*, a film on the role of artists during the movement against the Iraq War. The screening was followed by a question and answer session including artists Bob & Roberta Smith, May Ayres and the film's directors.

27.08.2009
The People Speak

30.08.2009
VHS Video Basement

10.09.2009
School of Oriental and
African Studies

12.09.2009
Exhibiting Guernica 1939–2009

Students from a young adult
summer school drawn from
countries across Europe, the
Middle East and Asia convened
to re-enact the UN Security
Council debates leading up to
the US invasion of Iraq in March
2003. The activity was organized
as part of the International
Foundation Courses in English
Language Studies (IFCELS)
programme at the School of
Oriental and African Studies
(SOAS), University of London.

Drawing upon personal memories,
contributions from local historians
and expert knowledge of Picasso's
relationship with party politics,
this symposium titled 'Contexts
and Issues' unpacked the social,
political and artistic significance
of *Guernica*'s display in the
East End, as well as its lasting
legacy for the community today.
Participants included writers
and historians Tom Buchanan,
Valentine Cunningham, Mike
Gonzalez, Lynda Morris, Paul
Preston and David Rosenberg.
The meeting was organized and
chaired by Michael Rosen, writer
and broadcaster, whose late father
Professor Harold Rosen visited
the original *Guernica* exhibition.
Personal accounts of the period
were given by Alice Hitchin
and Spanish Civil War Veteran,
Sam Lesser.

The People Speak aims to
bring about discussion in
an open-ended and fun way.
The group hosted one of their
'Talkaoke' events, which are live
mobile talk-shows, designed to
facilitate an exchange of ideas,
often between strangers. For
the meeting, The People Speak
placed their circular 'UFO of
Chat' next to the round table,
inviting visitors to join the
conversation.

A small scale screening and
discussion was held by the VHS
Video Basement (A free cinema
in Soho).

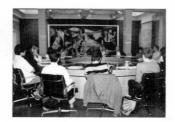

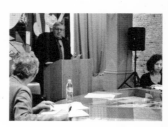

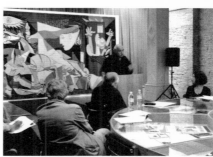

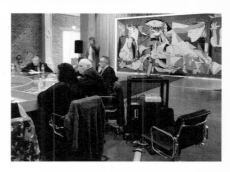

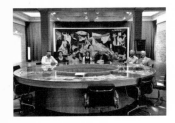

Richmond University, an American University in London, held a class from the series 'Art in Context' – this week learning about art, protest and critique.

A small group of A-level Drama and Media students met to work with their artist-in-residence on a play based on Charles Mee's *The Trojan Women*.

Andrew Burgin of the Stop the War Coalition hosted a meeting with a range of guest speakers, including local MP George Galloway, to highlight the arguments against the ongoing war in Afghanistan.

Teresa Dukes held a workshop for her clients on the theme of 'Turning Negative Experiences into Positive Outcomes'.

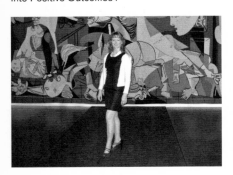

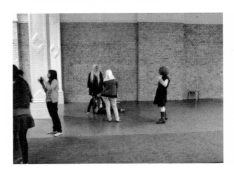

| 08.10.2009 | 10.10.2009 | 15.10.2009 | 17.10.2009 |
| St Benedict's School | Israel-Palestine Reading Group | Campaign for a New Workers Party | Lotos Collective |

Year 13 Spanish students from St Benedict's School in Suffolk gathered under the tapestry to discuss its symbolism and influence on the Spanish Civil War.

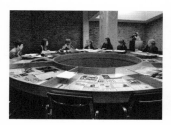

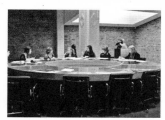

The Israel-Palestine Reading Group met to consider issues concerning the ongoing Israeli occupation. The group used John Berger's 2006 letter in support of a cultural boycott as a starting point for discussion. The meeting aimed to question the role that artists can play in the campaign against the occupation.

COME AND READ THE **GOLDSTONE REPORT 9 DEC, UCL** AN EXPERIMENT IN MASS EDUCATION BROUGHT TO YOU BY

!

THE ISRAEL PALESTINE READING GROUP

The Campaign for a New Workers Party hosted a discussion titled 'How can we build a left alternative to the rotten establishment parties?' addressing how to develop a new political voice for trade unions.

Titled 'Everyman, An Enquiry', Lotos Collective convened to investigate and define today's role of the Everyman from across disciplines, cultures and time. The dialogue served as a creative catalyst towards future workshops and the integration of Everyman into their developing projects. The discussion group was composed of a variety of invited artists, writers, educators, therapists, scientists and journalists.

| 24.10.2009 | 27.10.2009 | 27.10.2009 | 29.10.2009 |
| Latin America House | University of Westminster | Tower Hamlets Education Business Partnership | European Action Group on Climate Change |

Latin America House hosted the talk 'Latin American Participation in the Spanish Civil War' to discuss the participation of Latin American citizens in the Spanish Civil War and its repercussions in Latin America.

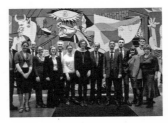

Tower Hamlets Education Business Partnership, a charity working to enhance the employability of young people in Tower Hamlets, held a team meeting around the table.

Filmmakers Phil Maxwell and Hazuan Hashim led a discussion on the damaging effects of climate change on Bangladesh.

East London Advertiser
5 Nov 2009

NEWS IN BRIEF

The issue of climate change is discussed at the gallery

TALKING ABOUT CLIMATE CHANGE

THE LESSONS learned from the impact of climate change in Bangladesh were discussed at a gathering at Whitechapel Art Gallery in front of a copy of Picasso's Guernica.

The event was organised by the European Action Group on Climate Change in Bangladesh in the run-up to the Copenhagen gathering of world leaders and guests.

Allama Siddiki, the Deputy High Commissioner of Bangladesh, described the pressures of climate change there.

Speakers considered issues including the cost of tackling climate change, the opportunities for developing carbon markets and international action needed to develop a global response to climate change.

Graduates from the MA course in Visual Culture at the University of Westminster held a meeting with Senior Lecturer Stefan Szczelkun.

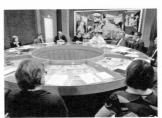

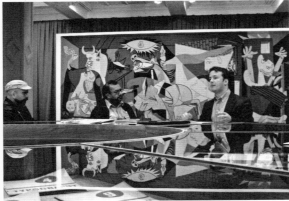

31.10.2009
Forum, Christ Church Spitalfields

05.11.2009
twentythirteen

12.11.2009
Summer University
Youth Ambassadors

14.11.2009
Simpletons Unite

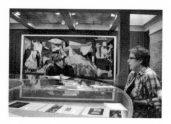

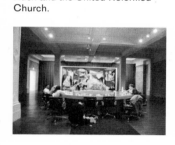

Forum, an arts and discussion group affiliated with Christ Church, Spitalfields, hosted the round table discussion 'Forum for Green Theology: can faith make a difference to the way we think and act on climate change?', with speakers from Cafod, Climate Rush and the United Reformed Church.

The inaugural meeting of the advisory board of twentythirteen, a community arts organization launching in Clapton Park, Hackney, was held in the space.

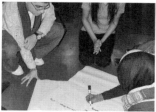

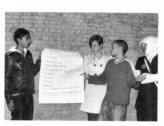

Tower Hamlets Summer University Youth Ambassadors met to find out how to get involved with Summer University and how they can play an integral part in the charity's development.

Investment club Simpletons Unite gathered for their November share club meeting to decide upon future investments, review previous investments and generally lose money in a really fun way over a long period of time.

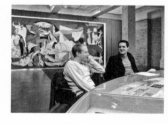

18.11.2009
Alternative Queen's Speech

21.11.2009
Movement for the Abolition of War

25.11.2009
London School of Economics

26.11.2009
Heritage Lottery Fund Committee

On the 30th anniversary of the United Nations International Year of the Child and during a time of perceived attacks on the freedoms of parents and children, the 'Alternative Queen's Speech: An Education Manifesto' was created in front of the UN's tapestry of *Guernica*. Leslie Barson, meeting organizer, and a group of young people lead by Home Educators Youth Council (HEYC), formed to fight the Badman review of home education, devising their own manifesto for the future of education.

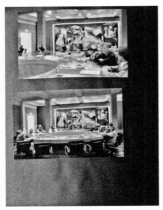

MAW organized an exhibition of quilts and arpilleras in London during November, entitled *The Human Cost of War* at the Imperial War Museum on Remembrance Sunday and at the St Ethelburga's Centre for Reconciliation and Peace. A dialogue was held, chaired by Roberta Bacic, curator of the exhibition, on the importance of quilts from various countries and arpilleras from Latin America in depicting the effects of military conflict and their value in the process of post-conflict reconciliation.

Titled 'Documenting Guernica: Historical Event and Painting', this talk was conducted in Spanish to students at LSE studying Spanish Language and Society. Given by artist Eva Bosch, the talk was based on the conception and development of Picasso's painting *Guernica*.

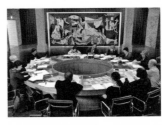

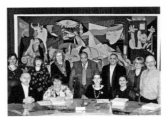

A meeting of the HLF London Committee was held around the table and was attended by the Chair of HLF Jenny Abramsky.

01.12.2009
Tower Hamlets Education
Business Partnership

02.12.2009
A World to Win

03.12.2009
Tower Hamlets ChangeUp
Consortium

10.12.2009
Live Artists

A meeting was held of the Reading and Number Partners Steering Group of the Education Business Partnership, a charity working towards youth employment. The group meets once a term to discuss the volunteer Reading and Number schemes within Tower Hamlets schools and is made up of EBP project managers, company representatives, school representatives and Borough Advisers. As well as being a chance to gain an update on current activities, the members have the opportunity to voice opinions and discuss innovative ideas pertinent to the development of Tower Hamlets' Partner Schemes.

A World to Win hosted the discussion 'Things can change – yes and walls can come tumbling down!' on the significance today of 1989, the year of revolutions. Poets and performers included Cristina Viti, Stephen Watts, Bros Grim, Adnan Al-Sayegh and Anirban Roy. Speakers included Bill Bowring, international human rights lawyer, Paul Feldman, Communications Editor, A World to Win, Ansar Ahmed Ullah and political theorist Mark Bartlett.

A consortium of members from Tower Hamlets based organizations, that offer support to voluntary and community organizations, held their regular meeting at the table.

A group of eight live artists and writers held their monthly meeting around the table to discuss issues surrounding their work, the nature of live art and performance, and to show and discuss new work in either early stages or completed form. Each member invited one person.

57

11.12.2009
PECANS

13.12.2009
Arts 4 Human Rights

15.12.2009
Department of History of Art,
University College London

12.01.2010
The London Group

PECANS committee is the
management committee for
a network of around 100
postgraduate research students
and early career academics from
across the world, who work in the
field of law, gender and sexuality.
They met to discuss administrative
matters and specifically an
upcoming workshop on 'Power'.

Titled 'What do "human rights"
mean to us?', Arts 4 Human
Rights held an initial research
meeting to discuss their approach
to exploring ways of highlighting
human rights/social justice issues
through the arts.

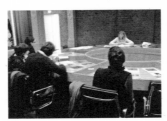

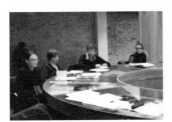

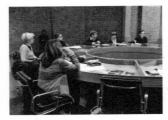

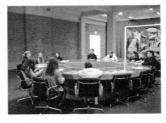

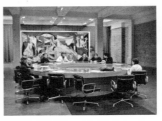

A study group from an
undergraduate course in History
of Art from UCL discussed
Goshka Macuga's work and other
contemporary artists' practices.

The London Group, an artists'
society founded in 1913 met to
discuss the Group's centenary
and its role and direction in
the future.

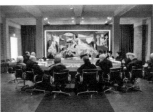

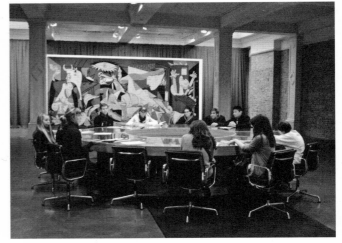

14.01.2010
City of London Partnerships Team

16.01.2010
Polish DeConstruction

20.01.2010
Historic Buildings Architects
& Surveyors Group

31.01.2010
Moscow Store of Culture

The City of London Partnerships Team hosted an away day to focus on team building and planning. The group's aim is to bridge the gap between the City and its neighbours and promote regeneration across the City fringe boroughs.

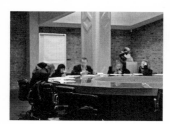

A society operating as a platform for Polish artists and designers in London met to discuss their projects.

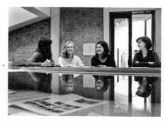

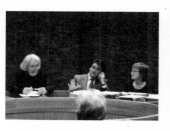

A discussion was held on the subject of archiving and curating objects of cultural value in contemporary and future Moscow, through the eyes of a proposed architectural project titled 'The Moscow Store of Culture'.

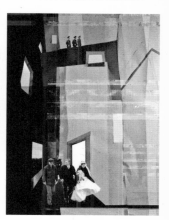

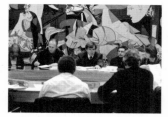

A peer group of specialists in conservation from English Heritage that meets every two months convened to discuss policy developments, casework and training.

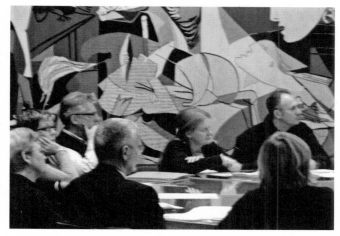

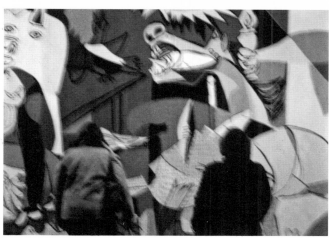

59

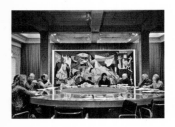

Take Part Research Cluster is a partnership organization made up of groups from the University of Lincoln, Goldsmiths, University of London, Manchester Metropolitan University, the Take Part Pathfinder Programme and the Take Part Network. They meet with the aim of developing research with Third Sector organizations concerned with the promotion of adult community-based learning for active citizenship, social justice and social solidarity. The group held a discussion on strengthening democracy titled 'Take Part National Dialogue on Strengthening Democracy'.

The University of the Arts London Marxist Society hosted a meeting exploring the Spanish Civil War titled 'Guernica: Lessons of the Spanish Civil War'.

Conscience campaign group discussed the effectiveness of non-military security and whether it is a viable option for national security. The meeting was titled 'Taxes for Peace not War'.

Stormont House school held a meeting to review and evolve its vision which aims to place creativity at the centre of teaching and learning, breaking down the barriers between subjects.

60

05.03.2010	13.03.2010	14.03.2010	16.03.2010
Enemies of Good Art	Unrealized Projects	The International Congress	BA Fine Art, Goldsmiths, University of London

Artist Martina Mullaney hosted the second of two discussions considering how artists continue to be productive after motherhood. It was chaired by Charlotte Cotton, Creative Director for The National Media Museum's forthcoming London galleries.

A group of artists met to discuss 'Unrealised Projects, Volume 4', and focused on bringing the project to a conclusion.

This meeting focused on representatives from 16 different countries gathered at the table to form a live human exhibition. The conference aimed to emphasize the rules of continental order and cultural identity whilst highlighting the sense of duty, individualism, thought process, and behaviour of each individual. Titled '119-Minute Circle', the International Congress also aimed to emphasize the lack of communication among people and the feeling of loss experienced by many.

Susan Kelly, Course Leader of BA in Fine Art & History of Art at Goldsmiths, organized a course seminar on Goshka Mauga's installation and its relevance to the students' practices.

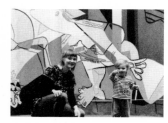

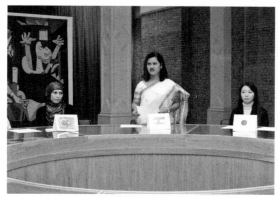

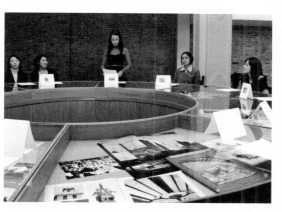

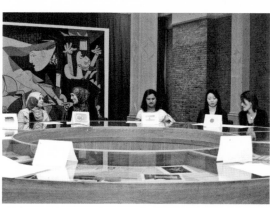

18.03.2010
Alternative Risk Transfer

20.03.2010
USA Gesamtkunstwerk 2012

25.03.2010
Creativity Matters Artist Forum

25.03.2010
The James Nayler Foundation

A live poker game was staged next to the tapestry where participating artists staked their own artworks. The game aimed to reveal artists' attitudes towards risk and competition and to explore how art is valued.

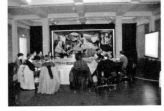

The forum met to focus on the Creativity Matters project, which is about embedding creative practice in primary schools in the London Borough of Ealing.

The James Nayler Foundation, a Quaker led mental health charity, organized a lecture and screening led by Dr Bob Johnson, a consultant psychiatrist, along with an invited panel of six experts. In his lecture titled 'The Cure for Violence: An End to War', Johnson outlined his ideas on what is required to build a violence-free society.

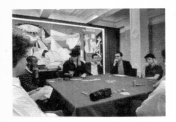

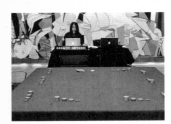

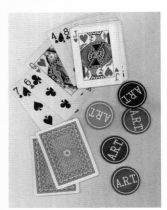

A group of artists met to begin a project that will take the form of an artists' road trip in 2012.

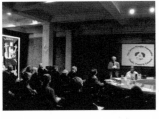

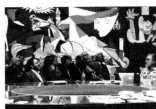

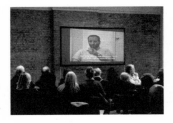

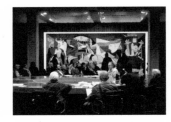

28.03.2010
Miss B's Salon

30.03.2010
The Landscape and Arts Network

01.04.2010
Art Network Agency

04.04.2010
Retort

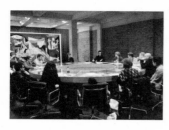

Artist Ruth Beale chaired the 21st 'Miss B's Salon' on the theme of 'Agency'. Miss B's Salons are regular discussion events chaired by Beale (Miss B) that bring together invited groups of artists, curators and interested parties to present and discuss their work and selected topics. They are frequently private and by invitation only but are also held in public galleries. Questions raised included: How does a work or reproduction of a work like *Guernica* gain or lose agency? Does what happens in art matter in the wider world? How does one reflect or express politics within ones work? What are the tactics of 'restating' in contemporary art practice?

The Landscape and Arts Network met to plan a strategy for the promotion of a greater awareness of global warming issues in artistic practices. The network aims to promote artistic activity in the environment, both natural and built.

Art Network Agency is a not-for-profit programme of the Hungarian Cultural Centre in London. Its aim is to stimulate cultural exchange between Hungary and the United Kingdom, focusing on the field of visual arts. The agency organized a meeting around the table.

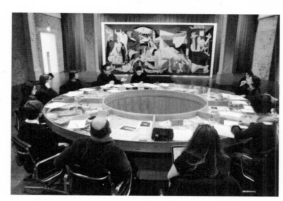

Retort hosted an open discussion titled 'You Know, The Horse...' on the topic of terror against civilians as an instrument of modern statecraft and the failed efforts of popular movements to halt it. The conversation focused on the notion that terror from the air is constitutive of modernity, and T.J. Clark's *Picasso and Truth*, where he argues that *Guernica* registers a double mourning – for the Spanish republic in its death throes but also for an end to modern humanity's hopes of a true space of belonging. The meeting asked what possibilities of renewal are there for an anti-war movement? How might 'art against war' be conceived under contemporary conditions of spectacle and the new arsenal of image machines? Retort is a group of artists, writers, artisans, and teachers, based in the San Francisco Bay Area and London, which has been active for over two decades in anti-war work.

Film
Programme

Guernica
Film by Antony Penrose, music by Juan Martin, 1984, 15 minutes

A Letter to the Prime Minister
Directed by Julia Guest, written by Jo Wilding, 2005, 71 minutes
Courtesy Year Zero Films

Welcome to Hebron
Directed by Terje Carlsson, 2007, 55 minutes
Courtesy Ekedalen Produktions & Mercury Media International

Fallujah: The Real Story
Directed by Ali Fadhil, 2005, 15 minutes
Courtesy Ali Fadhil and GuardianFilms, London

Sir! No Sir!
Written and directed by David Zeiger, 2005, 80 minutes
Courtesy Displaced Films

Winter Soldier
Produced by Winterfilm Collective, 1972, 23 minute extract
Courtesy Simon Hudson and Stoney Road Films

The Spanish Civil War
Green Umbrella Media, 1994, 52 minutes

Caught in the Crossfire
Directed by Mark Manning, produced by Rana Al Aiouby and Natalie
Kalustian, 2005, 18 minutes
Courtesy Conception Media

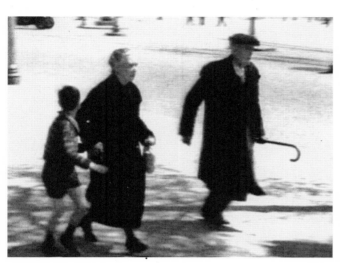

Baghdad Stories
Produced and directed by Julia Guest, 2003, 52 minutes
Courtesy Year Zero Films

Occupation: Dreamland
Directed by Garrett Scott and Ian Olds, 2005, 78 minutes
Courtesy Medici Arts International

Dieter Roelstraete

On the Nature of
The Nature of the Beast

The myths and legends surrounding Pablo Picasso's *Guernica* are made up of many strands, one of which tells of a German army officer's visit to the great artist's atelier in occupied, wartime Paris. Recognizing a sketch of *Guernica* pinned to the wall of the studio in Rue des Grands Augustins, the officer allegedly asked Picasso whether this was his work ('did you do that?'), to which the painter is said to have replied: 'no, you did'. The authenticity of this story cannot possibly be verified: Picasso himself (always a political sophisticate, as was amply demonstrated by the controversy around his famous – and missing – Stalin portrait of 1953) merely recounted the episode in an interview with American magazine *Newsweek*.

A more recent anecdote from the emblematic work's long, heroic history concerns *Guernica*'s improbable afterlife as the motif for a tapestry hung at the entrance of the Security Council room in the United Nations Headquarters in New York. This tapestry was commissioned by Nelson Rockefeller (a one-time president of the board of the Museum of Modern Art in New York, where the original painting was housed from 1939 until 1981) and presumably entrusted to the UN in the idle hope of fanning the flames of pacifism among the notoriously belligerent veto-wielding members of the Security Council. *Guernica*'s persistent power as a universal icon of anti-war activism was certainly reinforced by the UN's decision to cover up the tapestry at the time of Colin Powell's infamous speech to the Security Council during which the US Secretary of State made the case for a military invasion of Iraq.

This was not the first time a Rockefeller-funded artwork (or a *copy* of an artwork) met with such politicized censorship, though the other instance concerned a case, curiously, of self-censoring. In 1933 the Rockefeller family, an established presence in the liberal wing of the Republican party and one of the richest families in the world, had approached Pablo Picasso to paint a mural for the newly opened Rockefeller Center in midtown New York. When the Spanish painter (already one of the world's richest living artists at the time) refused on grounds concerning the autonomy of the artwork, the choice quickly fell to the Mexican realist Diego Rivera, whose subsequent creation included a portrait of Lenin – so unacceptable to Rivera's patrons that the mural, grandiosely titled *Man at the Crossroads Looking with Hope and High Vision to the Choosing of a New and Better Future*, was eventually destroyed. Soon after, Rockefeller Jr's political career took off in earnest with important contributions to the spreading of the gospel of economic liberalism in the countries of Latin America, as well as to the coordinated resistance against the rise of indigenous communist movements.

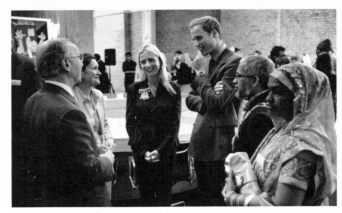

HRH Prince William with Iwona Blazwick, Whitechapel Gallery Director, at the reopening of Whitechapel Gallery, London, 2009
Courtesy Whitechapel Gallery Archive. Photograph Marcus Dawes

Members from the International Brigadiers Memoral Trust at the Lord Mayor's reopening of Whitechapel Gallery, London, 2009
Courtesy Whitechapel Gallery Archive. Photograph Marcus Dawes

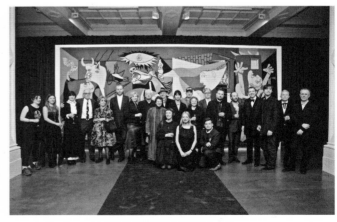

The reopening of Whitechapel Gallery, London, 2009
Back row left to right: Georgina Starr, Louise Wilson, Goshka Macuga, Richard Wentworth, Paula Rego, Wolfgang Tillmans, Cathy de Monchaux, Michael Craig-Martin, Bridget Riley, Patrick Brill, Gillian Wearing, Michael Landy, Rachel Whiteread, Rodney Graham, Juergen Teller, Paul Noble, Martin Creed, Mark Titchner, David Harrison and David Batchelor
Front row left to right: Cornelia Parker, Iwona Blazwick and Gary Webb
Courtesy Whitechapel Gallery Archive. Photograph Marcus Dawes

The tapestry, on temporary loan to the Whitechapel Gallery, was one aspect of a project by Goshka Macuga presented as part of the inaugural exhibitions of the redeveloped Gallery, which is located in what was one of the poorest neighbourhoods in London. The loan of the tapestry was made possible in part by Bloomberg, a financial services company which made its founder and majority owner, current mayor of New York City Michael Bloomberg, the richest resident of New York. Since its inauguration at the Whitechapel Gallery in April 2009, the room which held the *Guernica* tapestry for 12 months hosted meetings (ceremonial and otherwise) by a wide variety of groups and collectives. The space's principle of openness to receive anyone desiring to convene a meeting under the all-seeing eyes of the victims of the 1937 Guernica bombing raid was an integral part of Macuga's project. This mixture of political naivety and cunning certainly matches that of *both* its models, Pablo Picasso and Colin Powell (the latter immortalized in a cubist-style bust installed in the same room).

Although the British National Party, say, or the nuclear industry lobby did not offer to organize such a meeting at the Whitechapel Gallery, Macuga's ambitious experiment in participatory democracy produced its fair share of ambiguities, from a speech by a representative of the Royal House of Windsor (i.e. a real embodiment of the negation of democracy), to a gathering of art lovers (obviously) with ties to the weapons industry. It is the fate of art, as a frivolous luxury that may or may not claim to stake out a position of political commentary or intervention in society, to produce such unlikely 'coincidences', to generate this murky mesh of unsavoury allegiances and alliances. The art world is the place *par excellence* where many of us (artists, critics, curators, cultural producers of all stripes, many of whom hail from modest economic backgrounds) come closest to rubbing shoulders with the powers that be in the contemporary globalized world – which is to say, with the super-rich and wealthy. Where this wealth stems from is one question that can never be asked (let alone answered), for one of the basic tenets of capitalism holds that money, as the great equalizer and origin of equivalence, has no history, and its provenance cannot be called upon when judging its investment.

It is no longer a well-kept secret, and neither should it be a source of shock or indignant surprise, that 'anti-capitalist' art, or art that is 'critical' (of capitalism chiefly), should often be the most highly sought after, commanding some of the highest prices, keeping the basic structure of class society intact. Nor should we be scandalized to find that a woven mural depicting the twentieth century's most iconic pacifist symbol can so easily and effortlessly be reduced to a mere decor for the various forces of reaction to mingle among each other. In this, the artwork merely represents the intertwining of ornament and crime – in retrospect, therefore, that it should have become a woven mural (twice removed!), that most affirmative of ornamental forms, seems only just.

The tapestry of this tapestry (of that painting) also includes a portrait of the artist, guiltily looking away of course, dizzied by the *mise-en-abîme* her work has produced.

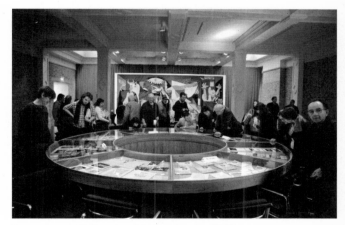

The reopening of Whitechapel Gallery, London, 2009
Courtesy Whitechapel Gallery Archive. Photograph Marcus Dawes

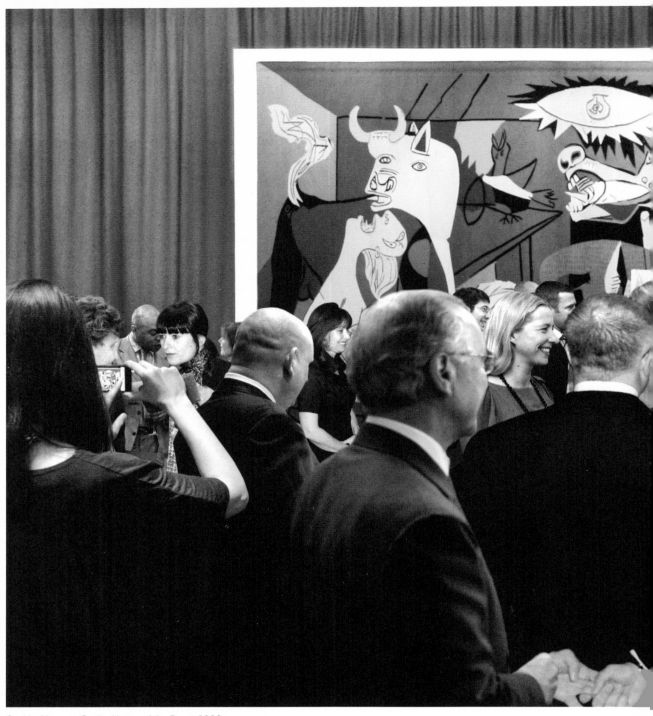

Goshka Macuga, *On the Nature of the Beast*, 2009
Courtesy MuHKA, Antwerp and Kate MacGarry, London. Photograph Clinckx

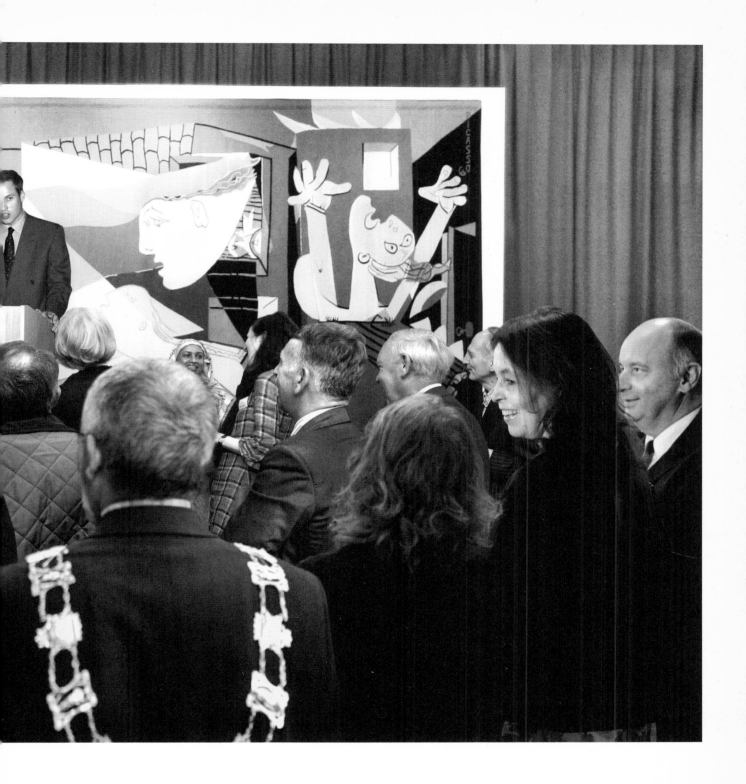

Biographies

Goshka Macuga was born in Poland in 1967. Solo shows include Zacheta National Gallery of Art, Warsaw and Walker Art Center, Minneapolis, both 2011; *I Am Become Death*, Kunsthalle Basel, 2009; *Objects in Relation*, Art Now, Tate Britain, 2007. Recent group shows include *everything is connected*, Castello di Rivoli, Turin and *Strange Comfort (Afforded by the Profession)*, curated by Adam Szymczyk, Istituto Svizzero, Rome, both 2010; *The Dark Monarch: Magic and Modernity in British Art*, Tate St Ives; *Textile Art and the Social Fabric*, Museum of Contemporary Art Antwerp (MuHKA); and *Fare Mondi/Making Worlds*, 53rd Venice Biennale, all 2009. In 2008 she was shortlisted for the Turner Prize. Macuga lives and works in London.

Cynthia Bronson Altman has worked for the Rockefeller family since the early 1970s. In 1991 she became Curator of the collections at Kykuit, the Rockefeller home in Pocantico Hills in New York State. Altman oversees the collections of twentieth-century outdoor sculpture, fountains and sculptural elements in the gardens and the fine and decorative arts within the house. She has published and lectured on the history of the collections and gardens, and has arranged exhibitions at Pocantico and The Rockefeller University in New York. She also advised on curatorial issues for the National Trust at the Philip Johnson Glass House in Connecticut and at The Rockefeller University. Altman is a graduate of Middlebury College, Vermont and received an MA in Art History from Columbia University in New York in 1977 specializing in Asian art.

A curator and writer, **Carolyn Christov-Bakargiev** is the Artistic Director of dOCUMENTA (13), Kassel, 2012. She was Chief Curator at the Castello di Rivoli Museum of Contemporary Art in Turin from 2002–8, and was interim director there in 2009. She has written several publications including *William Kentridge*, 1998 and *Arte Povera*, 1999. She was Senior Curator at MoMA P.S.1, New York from 1999–2001. Her exhibitions include *The Moderns*, Castello di Rivoli, 2003; *Faces in the Crowd*, Castello di Rivoli and Whitechapel Gallery, 2004; the first edition of the Turin Triennial, 2005; and in 2007–8 she was Artistic Director of the 16th Biennale of Sydney: *Revolutions – Forms That Turn*.

Pablo Lafuente is an editor of *Afterall* journal, Managing Editor of Afterall Books, and Associate Curator at the Office for Contemporary Art Norway (OCA), Oslo. He is currently researching the history of contemporary exhibition practice as part of Afterall's research and publication project *Exhibition Histories*; and exploring discourse-based programming models in the context of OCA, looking specifically at the relationship between modern and contemporary art forms and politics.

Sally O'Reilly is a writer, contributing regularly to many arts and culture publications, including *Art Monthly*, *Cabinet*, *Frieze*, *Art Review* and *Time Out*, and has written many essays for international museums and galleries. Her book *The Body in Contemporary Art* was published by Thames & Hudson in 2009 and she was co-editor of the thematic, interdisciplinary broadsheet *Implicasphere*, 2003–8. She has also curated and produced numerous performative events and is co-curator of the Hayward Touring exhibition *Magic Show*, 2009–10. She is currently writer in residence at the Whitechapel Gallery.

Dieter Roelstraete trained as a philosopher at the University of Ghent and works as a curator at Museum of Contemporary Art Antwerp (MuHKA). His curatorial projects there include *Emotion Pictures*, 2005; *Intertidal*, 2006, a survey show of contemporary art from Vancouver; *The Order of Things*, 2009; *Auguste Orts: Correspondence*, 2010; and the collaborative projects *Academy: Learning from Art*, 2006; *The Projection Project*, 2005–6, and *All That Is Solid Melts into Air*, 2009. He is an editor of *Afterall* and *F.R. David* as well as a contributing editor to *A Prior* magazine, and a tutor at both De Appel in Amsterdam and Piet Zwart Institute in Rotterdam. Roelstraete has published extensively on contemporary art and related philosophical issues in numerous catalogues and journals; his latest book, *Richard Long: A Line Made by Walking*, was published by Afterall Books/The MIT Press. He lives in Berlin.

Nayia Yiakoumaki is an artist, curator and the Archive Curator at Whitechapel Gallery. Born in Athens in 1967, she has recently completed a PhD thesis at Goldsmiths, London. She has lectured extensively in Athens and London. Since 2001 she has co-curated *FeedBack Project* and been co-editor of *FeedBack* periodical, a publication concerned with contemporary curating. Her art projects include a public art commission for the Athens Olympics, *Trajectorias* at the Museum of Modern Art, Rio de Janeiro, and *A-TOPIA* at the Goethe Institute in Athens.

Acknowledgements

The Whitechapel Gallery is grateful to the artist, contributors and lenders who have made this exhibition and publication possible, in particular Mrs Nelson Rockefeller and Kate MacGarry.

The Gallery thanks its supporters, whose generosity enables the realization of its pioneering programme.

With support from

Adam Mickiewicz Institute

The Henry Moore Foundation

Polish Cultural Institute

POLSKA! YEAR

Wingate Scholarships

With additional support from Kate MacGarry

Whitechapel Project
Major Donors
Arts Council England; Brian Boylan; City Bridge Trust; Cityside Regeneration; Dimitris Daskalopoulos; The Clore Duffield Foundation; English Heritage; Maryam & Edward Eisler; European Regional Development Fund; The Foyle Foundation; The Garfield Weston Foundation; Andrew & Antje Geczy; The Glass-House Trust; Richard & Janeen Haythornthwaite; Heritage Lottery Fund; Peter & Maria Kellner; Jack Kirkland; Brian & Lesley Knox; The Kresge Foundation; Leaside Regeneration; London Development Agency; David Matthews; The Mercers' Company; Keir McGuinness; Outset Contemporary Art Fund; Catherine & Franck Petitgas; Robert Taylor & Michael Kallenbach; Tishman Speyer Properties; Stavros Niarchos Foundation; Tower Hamlets; Dasha Shenkman; Bina & Philippe von Stauffenberg; Anita & Poju Zabludowicz; Nina & Michael Zilkha

Whitechapel Director's Circle
Fares & Tania Fares; Ella Krasner; Catherine & Franck Petitgas and those that wish to remain anonymous

Whitechapel Exhibition Patrons
Cranford Collection, London; Haro & Bilge Cumbusyan; Carolyn Dailey; Sarah & Louis Elson; Peter & Maria Kellner; Pascale Revert & Peter Wheeler; Renee & Mark Rockefeller; Maria & Malek Sukkar and those that wish to remain anonymous

Whitechapel Patrons
Charlotte & Alan Artus; Nasser Azam; John Ballington; Ariane Braillard & Francesco Cincotta; Hugo Brown; Sadie Coles HQ; Swantje Conrad; Alastair Cookson & Vita Zaman; Donall Curtin; DunnettCraven Ltd; Stephanie Dudzinski; Milovan Farronato; Nicoletta Fiorucci; Eric & Louise Franck; Alan & Joanna Gemes; David & Susan Gilbert; Gavin Graham; Louise Hallett; Cliff Ireton – Kingston Smith W1; Amrita Jhaveri; Matt & Kate Jones; David Keltie; Lisson Gallery; Victor & Anne Lewis; Keir McGuinness; Warren & Victoria Miro; Mary Moore; Dominic Morris & Sarah Kargan; Mummery Schnelle; Angela Nikolakopoulou; Simon Oldfield Contemporary Art; Maureen Paley; Dominic Palfreyman; Ketan Patel; The Porter Foundation; Tim Rich; Judith Ritchie; Alex Sainsbury & Elinor Jansz; Kaveh & Cora Sheibani; Peter & Flora Soros; Bina & Philippe von Stauffenberg; Hugh & Catherine Stevenson; Cynthia Taylor; Helen Thorpe, The Helen Randag Charitable Foundation; Christoph & Marion Trestler; Emily Tsingou & Henry Bond; Kevin Walters; Cathy Wills; Iwan & Manuela Wirth; Withers LLP; Richard Wolff; Anita & Poju Zabludowicz and those that wish to remain anonymous

The American Friends of the Whitechapel Gallery
Bill & Alla Broeksmit; The Nightingale Code Foundation; Jolana & Petri Vainio; Marjorie G Walker; Audrey Wallrock; Cecilia Wong and those that wish to remain anonymous

Whitechapel Associates
Anne Berthoud; John & Tina Chandris; Carole & Neville Conrad; Crane Kalman Gallery; Philippa Found; Nicholas Fraser; Albert & Lyn Fuss; David Gill; Richard & Judith Greer; Elizabeth & Reade Griffith; Karen Groos; Mark & Sophia Lewisohn; George & Angie Loudon; Kate MacGarry; Carol Manheim, Biblion; Janet Martin; Penny Mason & Richard Sykes; James & Viviane Mayor; Wiebke Morgan & Nicholas Morgan; Lord & Lady Myners; John Newbigin; Chandrakant Patel; The Piccadilly Gallery; Lauren Prakke; Paul & Charlotte Pritchard; Alice Rawsthorn; Jon Ridgeway; Fozia Rizvi; David Ryder; Cherrill & Ian Scheer; Karsten Schubert; Stuart Shave, Modern Art; Henrietta Shields; Liam & Jackie Strong and those that wish to remain anonymous

The Whitechapel Gallery is grateful for the ongoing support of Members

Supported by ARTS COUNCIL ENGLAND

TOWER HAMLETS

Chairman of the Trustees
Robert Taylor

Trustees
Duncan Ackery
Ed Eisler
Ann Gallagher
Runa Islam
Cllr Lutfur Rahman
Michael Keith
Keir McGuinness
Farshid Moussavi
John Newbigin
Dominic Palfreyman
Atul Patel
Catherine Petitgas
Alice Rawsthorn
Andrea Rose OBE
Sukhdev Sandhu
Nitin Sawhney
Alasdhair Willis

Company Secretary
Tom Wilcox

Director
Iwona Blazwick OBE

Whitechapel Staff
Chris Aldgate
Sarah Auld
Sarah Barrett
Achim Borchardt-Hume
Jussi Brightmore
Tara Brown
Emily Butler
Beth Chaplin
Zanna Clarke
Tom Clarke
Emily Daw
Michael De Guzman
Emily Doran
Sue Evans
Elizabeth Flanagan
Michele Fletcher
Annette Graham
James Greene
Gary Haines
Katherine Hart
Clare Hawkins
Sophie Hayles
Daniel Herrmann
Quay Hoang
Caro Howell
Annabel Johnson
Richard Johnson
Chris Larner
Jon-Ross Le Haye
Patrick Lears
Selina Levinson
Rachel Mapplebeck
Zoe McLeod
Jo Melvin
Patrick Millner
Anthony Moat
Cassandra Needham
Maggie Nightingale
Kirsty Ogg
Rebecca Page
Dominic Peach
Alex Pearson
Faheza Peerboccus
Chris Potts
Cookie Rameder
Sherine Robin
Charlotte Settle
Shamita Sharmacharja
Nicola Sim
Maija Siren
Sarah Smillie
Marijke Steedman
Candy Stobbs
Andrea Tarsia
Hannah Vaughan
Natasha Vicars
Sarah Walsh
Tom Wilcox
Nayia Yiakoumaki

This catalogue has been published on occasion of the exhibition

Goshka Macuga:
The Nature of the Beast

Whitechapel Gallery, London
5 April 2009 – 4 April 2010

Exhibition
Curator: Anthony Spira
Organizer: Cassandra Needham
Assistants: Will Cooper and
Elizabeth Eames
Meetings: Sara Angel Guerrero-Rippberger, Edmund Cook,
Barnaby Lambert and Nicola Sim
Installation: Chris Aldgate and
Patrick Lears

Publication
Editor: Kirsty Ogg, Curator
Assisted by Cassandra Needham
and Paula Morison
Design: Fraser Muggeridge studio
Printing: Editoriale Bortolazzi-Stei

Cover image
After Picasso, woven by
Mme J. de la Baume Dürrbach
Guernica tapestry (detail), 1955
Collection of Mrs Nelson A.
Rockefeller

pp. 1–5
Goshka Macuga
The Nature of the Beast, 2009
Installation views, Whitechapel
Gallery, London
Courtesy the artist and
Whitechapel Gallery Archive

pp. 6–7
Goshka Macuga
The Nature of the Beast, 2009
Installation view with
Sir! No Sir!, 2005
Written and directed by
David Zeiger
Courtesy the artist and
Whitechapel Gallery Archive

p. 8
Goshka Macuga
The Nature of the Beast, 2009
Installation view with
Colin Powell, 2009
Modelled by Aleix Barbat
and Hero Johnson
Courtesy the artist and
Whitechapel Gallery Archive

Photography by Patrick Lears
unless otherwise stated

First published by
Whitechapel Gallery
Ventures Limited
77–82 Whitechapel High Street
London E1 7QX
United Kingdom
Tel. +44 (0)20 7522 7888
Fax.+44 (0)20 7522 7887
info@whitechapelgallery.org
www.whitechapelgallery.org

 Whitechapel Gallery

Printed in Italy

Distribution
To order (UK and Europe) call
+44 (0)20 7522 7888 or email
mailorder@whitechapelgallery.org

Distributed to the book trade
(UK and Europe only) by Central
Books www.centralbooks.com
ISBN: 978-0-85488-180-2

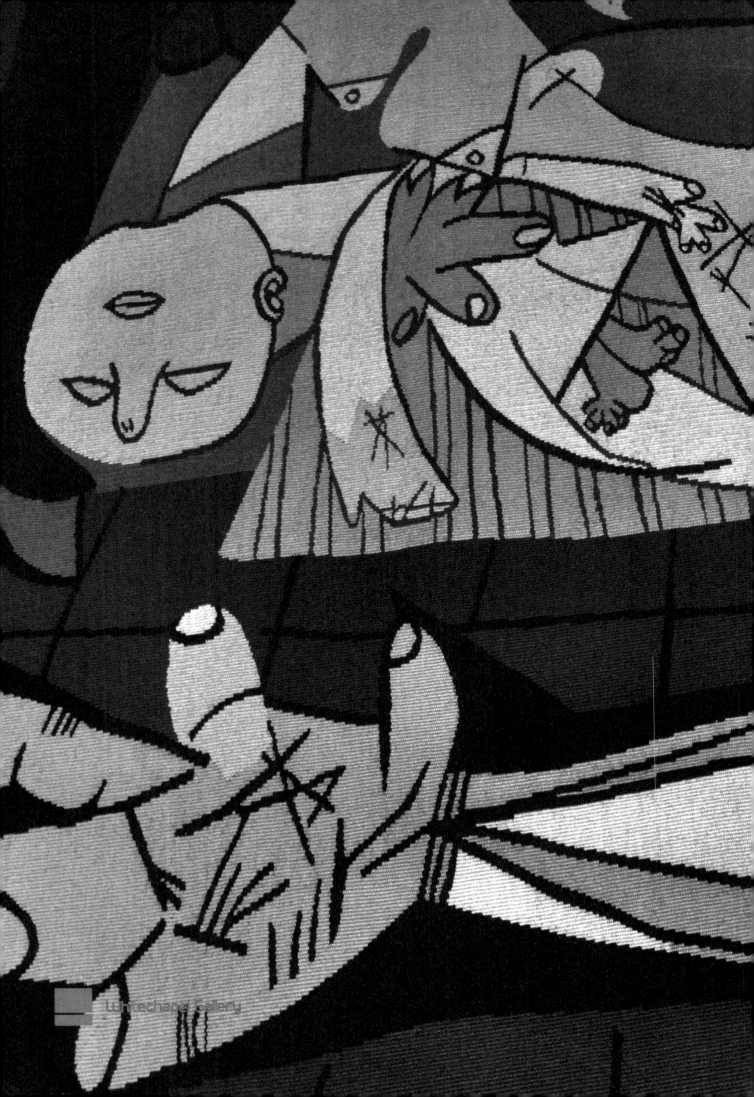